The History of the Church through 100 Masterpieces

Jacques Duquesne and François Lebrette

Translated by M. Cristina Borges

D1591361

DUQUESNE UNIVERSITY PRESS
Pittsburgh, Pennsylvania

First published in French under the title
L'histoire de l'Eglise: À travers 100 chefs-d'oeuvre de la peinture
Copyright 2005 © Presses de la Renaissance, 12 avenue d'Italie, 75013 Paris, France
Photo Credits: Akg-images

English translation copyright © 2011 Duquesne University Press
Translator's introduction copyright © 2011 Duquesne University Press
All Rights Reserved

No part of this book may be used or reproduced, in any manner or form whatsoever, without written permission from the publisher, except in the case of short quotations in critical articles or reviews.

Published in the United States of America by
DUQUESNE UNIVERSITY PRESS
600 Forbes Avenue
Pittsburgh, Pennsylvania 15282

Cet ouvrage publié dans le cadre du programme d'aide à la publication bénéficie du soutien du Ministère des Affaires Etrangères et du Service Culturel de l'Ambassade de France représenté aux Etats-Unis.

This work received support from the French Ministry of Foreign Affairs and the Cultural Services of the French Embassy in the United States through their publishing assistance program.

Library of Congress Cataloging-in-Publication Data

Duquesne, Jacques, 1930–
 [Histoire de l'église. English]
 The history of the church through 100 masterpieces / Jacques Duquesne and François Lebrette ; translated by M. Cristina Borges.
 p. cm.
 Summary: "Designed to highlight the deeper meanings in 100 paintings, reproduced here, that were inspired by events in Christian history; the authors provide brief descriptions of each painting to discuss both the historical events and the religious and cultural background surrounding them" — Provided by publisher.
 ISBN 978-0-8207-0437-1 (pbk. : alk. paper)
 1. Church history. 2. Catholic Church — History. I. Lebrette, François. II. Title.
 BR145.3.D8713 2011
 270.022'2—dc22

 2011009631

∞ Printed on acid-free paper / Printed in Canada

Contents

Translator's Introduction

"And I say to thee that thou art Peter; and upon this rock I will build my church, and the gates of hell shall not prevail against it" (Matt. 16:18). This seminal statement of Christ says two things: one, that he established his church on the very human—Peter, whom he knew would waver and even deny him before being confirmed in the Holy Spirit; two, that hell, or, as St. Paul put it, "the principalities and powers . . . the rulers of the world of this darkness" (Eph. 6:12) shall not triumph over it. They may rock it, they may cause havoc, but ultimately, the work of the church continues, individual by individual, soul by soul.

The foundation is God's, despite the human instruments; and what else would the "principalities and powers" use against it but human weakness? This is only too apparent as one examines the annals of the 2,000 year history of Christianity, something that the following pages aptly capture.

But the present book—not meant as a scholarly treatment so much as an ongoing story—is not only a pictorial description of events that succeeded each other throughout the 20 centuries of church history. It examines certain points of doctrine and the life of Christians. "The Celebration of Baptism," "The Polemic on Purgatory," "The Emergence of the Virtues," and other such topics are visited, demonstrating the work of the church itself apart from human affairs.

Originally written and published in French, it is natural that, here and there, the book offer subjects more reflective of French history. But the long and rich history of the church in France is both informative and relevant to any audience, Anglophone included.

Foreword

European art does not offer an exhaustive view of the history of the church. Artists are not historians, and their work cannot reflect every moment of what constitutes an overwhelming chronology. Some events do not readily lend themselves to illustration; other episodes, painful to the faithful, did not merit inclusion here in cases where the canvas was used as an instrument of apologetics by the artist or commissioning patron. Yet even these lacunae are part of history. The artworks reproduced here provide a faithful image of the perception Christians have had of their faith across the centuries.

Introduction

What sentiments moved the disciples, the companions of Jesus, on Easter morning and after he had departed from them? Were they overwhelmed, flabbergasted, enthused, inspired, enlightened? It is difficult to say, but one thing is certain: these men and women wondered about and pondered the events they had witnessed. They sought to comprehend the unbelievable, a series of events that did not correspond at all to what they had previously imagined.

Following this man along the routes of Galilee (and less often in Judea), this rabbi, preacher, and thaumaturge, they had imagined him eventually sitting on the throne of David. Or better — perhaps he would be an emperor, like the one in Rome. Better still, in the place of the one in Rome. Instead, he was imprisoned, tortured, and condemned to the most infamous of deaths: death on a cross.

But he had triumphed over this death. He had returned; he had risen. And they believed this.

History will never come to a definitive pronouncement on this point. No one can give absolute credence to Mary Magdalene's cry, returning from Golgotha on that Easter morning: "He lives!" Those same men who had denied him after his arrest came to the tomb to verify her words and found it empty. Then they themselves saw him. And what they saw was not a ghost; they were not dreaming. The best proof of this is that he ate with them. The apostles would never back down from this conviction, even to the point of martyrdom, as we know with certainty in the case of those whose history can be traced.

Nonetheless, after his departure, they still had questions about the meaning of what they had experienced, about what he had told them and taught them, and above all, about what they were now to do.

To be sure, they knew they should continue, as he had frequently told them. He had said so to Mary Magdalene when he met her by the tomb on Easter morning, in words charged with meaning: "Do not hold me" (in Western tradition the Latin translation is:

1

Noli me tangere — "Do not touch me"). "Do not hold me, but hasten to my brothers." This celebrated passage of the Gospel of John demonstrates that Christianity is not based on the cult of the dead, on visits to cemeteries and memorial monuments. Rather, it is a religion of motion, of proclamation. Another version of the words of Jesus to Mary Magdalene reads: "Do not remain here by the tomb, but go tell the community that I will ascend to my Father."

"Community"… a word for us to ponder, since the followers of Jesus were at that point only a small group. It evokes a question that has endured for 20 centuries: Did Jesus intend to found a larger community, an immense and lasting one — the church? Any history of the Christian church must begin with this query.

At the center of this debate is a passage from the Gospel of Matthew. It relates that shortly after the multiplication of the loaves, Jesus asked his companions a question calculated to test them: "Who do you say I am?" While the crowds considered him a magician or a new prophet or a future revolutionary leader (riots and rebellions were then a common thing in Galilee), Jesus compelled his disciples to commit to a position. It was Peter who responded: "You are the Christ, the Son of the living God."

Christ was the word used in the Greek translation of the Jewish Bible of the third century B.C. to designate the ideal king, the awaited Messiah. With his words, Peter placed Jesus outside the common sphere of humanity. He did not say, "You are God yourself," but he was not far from saying so. Jesus then replied, "And I tell you, you are Peter [Rock], and on this rock I will build my Church."

Catholic tradition has adduced from this sentence both an affirmation of the intention of Jesus to create the church and evidence of the primacy of Peter and his successors. On the other hand, there are many who point out that this text does not appear in other accounts of the same scene as written in the Gospels of Mark and Luke, but only in the Gospel of Matthew. The question arises, then, if the passage might not have been inserted at a later date, a question that cannot be answered with any certainty. While it is possible that the passage was not included in the first version of the Gospel of Matthew, it is certain that it is very ancient. Justin, a Christian of the second century, cites the text in his *Dialogue with Trypho,* which was written to counter the objections of a questioning Jew. Tertullian of Carthage, who at the beginning of the

third century was the first Christian author to write in the Latin language, also mentions the same passage.

Another matter of controversy is the use of the word *church*. It rarely ever occurs in the Gospels, and then, never in the sense that we give it today. The Latin word *ecclesia* means assembly, and, according to the majority of scholars, there is no corresponding expression in Aramaic, the language used by the first companions of Jesus. Neither does the word *church* appear in the writings of Saint Peter, who prefers to use terms such as "house of God," "people of God," "God's flock," or "spiritual house." Thus, there would be a certain logic to translating the words of Jesus as "You are Peter and on this rock I will build my house." The solution to this problem is best supplied by Paul when he writes to Timothy, his principal collaborator, "I wish that you may know how one ought to behave in the house of God, which is the church of the living God." Thus, Paul passes, in a significant way, from one term to the other, and it is the word *church* that prevails.

As to the word *Christian,* it appears for the first time in Antioch, the Roman capital of Syria — at the time the third largest city of the empire — used in reference to the disciples of Jesus who had taken refuge there from the persecutions in Jerusalem.

These questions are not unimportant, as they concern the beginnings of an institution that would change the history of the world and that still holds a prominent place in our society. They provide evidence that after the departure of Jesus a handful of peasants and fishermen and women felt charged with a mission. They would continue to carry on his work, furthering the community he had created; they would testify to his resurrection and communicate his message.

Thus arose in Palestine, in the course of the fourth decade of the first century, the first rudiments of the church. This small community would perform three tasks: organize itself, spread the teachings of Jesus, and analyze them so as to better understand them.

As regards organization, the first Christians continued frequenting the Temple in Jerusalem, so that at first they were considered a Jewish sect with a communal spirit that sometimes could be pushed to a utopic extreme. The Acts of the Apostles — a text of the New Testament that is attributed to the evangelist Luke — describes this collectivist dream: "All those who believed shared all things in common; they would

sell their property and goods, dividing everything on the basis of each one's needs." A somewhat idyllic vision.

This communal life could not possibly have continued as the number of converts grew and the Christian faith spread, giving rise to local churches. In the first century, these numbered about 30, almost all of them located along the eastern borders of the Mediterranean, with the notable exception of Rome. Their number increased slowly during the second century, with a few churches established in northern Africa, Gaul, and central Europe.

Obviously, the apostles — who reportedly did not live very long — were not alone in spreading the good news. Local churches were soon governed by groups of "elders," called by diverse names — such as guardians, shepherds, and finally bishops — who were considered the successors of the 12 apostles.

They, in turn, were assisted by deacons, auxiliaries whose function was at first very material. At one point, the apostles evidently convened the first community of Jerusalem to let them know that "It is not right for us to neglect the word of God in order to wait on tables. Therefore, brethren, pick out from among yourselves seven men of good repute, full of the Spirit and of wisdom, and we will appoint them to this duty. As for us, we will continue to devote ourselves to prayer and the ministry of the Word." But the deacons did not limit themselves to minor tasks. Very soon they were engaged in activities of primary importance, such as managing the finances of the community, organizing the liturgy, and being responsible for works of charity.

Priests, in the present-day sense of the word, did not actually appear until the beginning of the third century. This term was at first reserved for Christ, and then applied to the Christian people as a whole. However, the proliferation and growth of Christian communities necessitated the formation of a new cast of ministers (or servers) of the church, who were associated to the bishops (the Greek term *episkopoi* means overseer), operated under their authority, and were charged with presiding at the Eucharist, which would become the Mass. The creation of a "clergy" can be traced to this period.

Christian communities kept close ties to one another, exchanging messages and helping one another, and they sensed the need for a more permanent bond. Jesus had accorded a type of primacy to Peter, but in the context of the group of 12 apostles

and thus the sense of collegiality that reigned among them. The expression "Peter and the Apostles" occurs repeatedly in the New Testament, and when Peter spoke, it was always in the name of all others — the word *we* was a familiar term to him. Toward the year 60, he had come to Rome where he was martyred, so Peter's acknowledged primacy gradually came to rest upon his successors in the Eternal City. They were given the name *pope,* from the Greek *pappos,* an affectionate term of veneration found in Homer, and from the Latin *papa,* "father." In the course of the centuries, these fathers would become monarchs. The Second Vatican Council, held in the twentieth century, would insist, however, on the point of collegiality.

As interesting and significant as the organizational development of the church may be, it is less important than the elaboration of its faith, its dogmas and doctrine, which was marked with many a conflict.

The first conflict is well known. While Jesus exhorted his disciples to announce the good news to the entire world, the greater part of them, in Jerusalem, limited their preaching to Jews alone. Unlike them, Stephen followed this command of the Resurrected One at the risk of departing from orthodox Judaism. Stephen belonged to a group called the Hellenists, Jews who spoke Greek and were somewhat estranged from the traditions of their religion. Stephen's path, of course, did not come without a cost: the chief priests had him executed after a summary trial, thus giving rise to the first great persecution of Christians.

Many of the faithful, fleeing Jerusalem, spread their faith throughout the neighboring regions. But the question remained: could non-Jews be accepted into Christian communities? The matter was resolved largely through the insistence of Paul, who had participated in the persecution of the Hellenists before his startling encounter with Jesus on the road to Damascus. A Jew, he was also a Roman citizen imbued with Greek culture. Already belonging to three different worlds, he was well equipped to become the greatest of the missionaries. He mediated the admission of the "uncircumcised" (as they were called) into the community, and thus, thanks to Paul, the church became "catholic," that is, universal (from the Greek *katholikos*).

The other great conflicts that arose in the course of church history concerned the matter of the Incarnation. Christianity, unlike other major religions, professes that a

man was God, and that God became human, something that continues to baffle many in our day, as it did from the very beginning.

Justin—a Christian of the second century, who taught in Rome before being martyred—gives expression to the issue in his dialogue with an imaginary Jew called Trypho. The latter, astounded, states, "You endeavor to prove an incredible and well-nigh impossible thing, namely, that God would deign to be engendered and become man." God is the Most High, the All Other; for a Jew, to mix God with the created, the human, is nothing short of blasphemous.

The idea of the Incarnation was just as difficult a concept for the Greeks, whose philosophy reigned supreme at that time in all the countries of the Mediterranean. Their literature contained plenty of god-men who shared the passions common to everyone, but in this the gods lost their divinity. To the numerous disciples of Plato, the body—contrary to a then widespread notion—was something contemptible; it was but a prison, the enemy of the soul. If the body had to be cared for and developed, this was only so that it could be forgotten; if beauty was an ideal, it was only as a reflection of the soul.

In short, almost no one could easily believe in the Incarnation, beginning with the apostles themselves, judging from certain passages in the New Testament (with the exception of the Gospel of Saint John). Therefore, their first successors had to struggle with a variety of detractors. For example, there was Marcion, who was born toward the end of the first century, by the Black Sea in today's Turkey. For him, the world was evil, matter was contemptible, and Jesus had not really been born of a woman; he had "passed through" her, just as water runs through a pipe. Had there been anything human in Jesus, it would have had to be evil; therefore, he could not be truly human.

Another dissenter was the orator Arius, a phenomenon who, to disseminate his doctrine, went so far as to compose popular songs that, sung by the dockhands of the Mediterranean, spread from port to port. Arius did not deny the humanity of Jesus, but rather his divinity. If Jesus was the son of God, he could not have existed from all eternity, and therefore, he could not be God himself. Arius was very successful, perhaps not the least because the code of moral behavior he advocated was not all that constraining.

It was at this period (fourth century) that the Roman emperor Constantine converted to Christianity. He used his new religion as an instrument of power, and all these disputes, which brought disorder in their wake, annoyed him, particularly as he had no taste for theology. He convened a council—that is, an assembly of bishops—at Nicæa and directed the meeting himself in the absence of the pope. Thus was promulgated, in 325, the *Credo*, or Creed, which is still recited by the faithful today. In it, Christ is defined as "true God of true God; begotten, not made, consubstantial with the Father." Arius and his followers were excommunicated, as well as two bishops who refused to vote on the text.

However, Arianism did not disappear. It was disseminated throughout Western Europe by the invading barbarians. The church aligned itself with Clovis and his Franks, precisely because they were the exception: though pagans, they were not Arians.

The Nicene Creed launched a new era in the church for yet another reason. Until then, converts to Christianity had affirmed their faith using a wide range of texts, which they learned (except in the earliest days) during a period of formation prior to their baptism. After Nicæa, they followed one single and uniform text. The clergy assumed the responsibility of instructing these catechumens through an intense course of study carried out during the weeks preceding Easter (during the season we have come to know as Lent). Consequently, starting in the second century, the majority of baptisms took place on Easter.

Constantine, and his sons after him, contributed to the expansion of Christianity. However, the debates continued, often violently and mixed with political interests. A number of councils followed one after the other. In the middle of the fifth century, the Council of Chalcedon (located opposite Constantinople, on the other side of the Bosphorus strait) occupied iself with Monophysitism, a doctrine that considered the two natures of Christ (human and divine) to be so intimately united that the divine overwhelmed the human, effacing it altogether. This council was dominated by the bishops of the Eastern Church. The pope, however, had sent two deputies from Rome who took recourse to a blackmailing of sorts: "If you do not listen to us, we will call another council in our part of the world." Both parties ended by agreeing to a formula according to which Jesus is of the same nature as God the Father and also the

same nature as man, "like unto us in all things, but sin," true man and true God, so that "the distinction in natures is in no way suppressed by their union." The text issued by the Council of Chalcedon, which settled once and for all the theology of the Incarnation, can be considered the founding charter of Christianity. However, some Eastern churches did not accept it and detached themselves from the communion.

Indeed, this did not put an end to debates and conflicts. No council has ever brought about union; all of them, to our day, have been followed by dissent.

Nonetheless, the church continued to develop. The end of the third century saw the rise of asceticism, a movement that would eventually lead to monasticism. Ascetics, or monks, aspired to live the Christian life in all its plenitude, and believed that contact with the world was a major obstacle to this goal. (Thus, Saint Basil the Great, who studied in Greece before returning to his native Cappadocia, desired to free the soul from the "chains of the body.") At first leading an isolated life as hermits, these monks eventually came together to live in community, for example, at Ligugé with Saint Martin of Tours, or in the island of Iona with Saint Columba. However, it was an Italian, Benedict of Nursia (480–547), who wrote the rule of life that established the pattern for Western monasticism, built upon two pillars: prayer and work (*ora et labora*, as goes the Benedictine motto).

Then a new religious call resonated, with considerable repercussions upon the history of Christianity and of the world: in 610, Muhammad proclaimed the message of Islam. With this, the center of gravity of the church shifted toward the West, and church authorities sought greater support from political powers. After its collapse under the blow of the barbarian invasions, Pope Leo III revived the Western Roman Empire on Christmas of the year 800 by crowning Charlemagne emperor. Seeing himself as a representative of God, Charlemagne proceeded to reform the church and utilize its bishops as if they were prefects. At the same time, theological debates continued. A French abbot of Corbie by the name of Radbert (785–856) wrote in a treatise, for the first time, that the body and blood of Christ were "truly" present in the host and wine consecrated at Mass.

In the East, the Muslims attacked, and the Byzantine Empire rocked. Another Leo III (685–741), this one an emperor, humiliated by repeated defeats against the

Muslims and terrified by a devastating earthquake, accepted an idea circulating among a portion of his people: God was punishing Christians because, by adoring their icons, they had become idolaters. He ordered that all religious images in churches and public places be removed or destroyed. Rome voiced its opposition, and the confrontation over iconoclasm poisoned relations between East and West. More than a century later, the regent empress Theodora finally put an end to the controversy, but the affair had left its scars.

The Orthodox schism was not a direct result of iconoclasm; rather, it was an expression of the divide that had been gradually drawing the West and East further and further apart, as exemplified by the iconoclastic controversy. It was both a cultural and political divide. The Carolingian, and later Germanic, emperors wanted to consolidate the transfer of power to the West, in their favor, and so accused the Greeks of heresy.

Small quarrels took on larger proportions until they finally blew up into the great doctrinal debate over the *filioque*. This time the controversy revolved around the Trinity. Simply put, the pope affirmed that the Holy Spirit proceeded from God the Father *and the Son* (*filioque*), while the Eastern party thought that the Spirit proceeded from the Father *through the Son*. Before insulting each other, the two sides made an attempt at reconciliation. In 1054, the patriarch of Antioch wrote in a letter to Rome that if the West would consent to suppressing the problematic word, he would demand "nothing more, consigning all else to the realm of indifferent matters." But the "Latins," as they were called in Antioch, did not give in. To make matters worse, the pope appointed a Latin patriarch for Constantinople, which was perceived in Byzantium as nothing short of ecclesiastical colonialism. And so arose the Orthodox Church, which would soon convert and civilize Eastern Europe from the Caucasian mountains to the Carpathians and into the polar circle. The hatred that grew from these conflicts between Rome and Antioch would eventually drive a crusade to sack Constantinople in 1204 and destroy its icons.

While the Crusades contributed to the schism, in the eyes of the papacy they were primarily efforts to regain the Holy Land from the hands of the Muslims (who actually respected the holy places). Also, during this period, the West, now risen from

its slumber, wanted to exert its power. Demographic expansion, agricultural develop-ment, the conversion of brigands into feudal lords, and the reinvigoration of cities and international commerce had generated wealth. As much inspired by the spirit of adventure, the prospect of gain, and the lure of the riches of the Orient as by religious motives, the Crusades were a manifestation of the power of Christian Europe. The papacy reaped some benefit from them; Christianity as a whole, much less so.

Nevertheless, the church was experiencing a period of grandeur. This was the time of the building of Gothic cathedrals, the flourishing of Marian devotions, the estab-lishment of new regulations on the sacraments of marriage and confession. But more tribulations were looming on the horizon.

First was the exile of the papacy in Avignon. Pope Clement V, archbishop of Bordeaux in France, whose election to the papacy took place in Rome — was crowned in Lyons and, swayed by factions in France, never left French soil for the Eternal City. Instead, he temporarily installed himself in Avignon, where he died. The pope who followed, Benedict XII, had a palace built in Avignon befitting the papacy and its administra-tive exigencies, which contributed to his successors' remaining there, living royally. One of them, Clement VI, had for his motto: "Bestow benefices lavishly, give money away lavishly." It is not hard to see why the great plague of 1348 was perceived to be a chastisement for the sins of the papacy at this time. Referred to as the Babylonian Captivity of Avignon, this episode lasted only from 1309 to 1377, but left its mark on the prestige of the papacy.

Other trials followed. After the papacy's return to Rome in 1378 until 1417, there were two, or at times three, rival popes at once, avid for power, money, revelry, and women. However, the competition among them was not entirely detrimental to the church; it seemed at one point that the church would be able to govern itself apart from the papacy. This actually happened during the Council of Constance, a period of three and a half months in 1417, when there was no pontiff at all. However, the bishops at the council did end by choosing a pope, Martin V, who hastened to dissolve the body that had elected him. After some bouts of revival, the collegiality of councils faded away. Some have suggested that, had this continued, the Reformation might have been avoided — but, of course, history cannot be rewritten.

The Protestant Reformation was certainly the most violent rupture in the history of the Christian church, and the most laden with adverse consequences. There were many causes for the rupture, but they were essentially religious. Some would like to associate the movement with the beginnings of capitalism, which is only a parallel aspect of the whole picture.

At the end of the Middle Ages there was a marked emphasis placed on the devil, concurrent with the rise in belief in purgatory, a place between hell and heaven, where sinners who had been saved were consigned to purgatorial flames in order to expiate for their sins. Their dear ones on earth could help reduce their sufferings through prayer and by having masses offered for their repose. Some members of the clergy even began to sell these "indulgences."

The scandal of simony contributed to the revolt, but also demonstrated how ardently the people desired salvation in the next world. They were aware of the abuses of the clergy, and they condemned them. But if they listened to Luther, it was because he went well beyond denouncing Roman corruption. Luther changed the face of God, from a judge desirous of inflicting punishment, to a father who gave himself to human beings through grace. This opened a debate — obscure for most Christians, but nonetheless of fundamental importance — over the theory of justification. God, the "only just one," justifies human beings by granting them salvation. Thus we are *in the course of being saved*. ("We were saved, but in hope," wrote Paul in his epistle to the Romans.) Saved in what manner? By faith? Or by our merits, our works? "By faith," would reply Luther. According to him, good works and merit were not the cause of salvation but its consequences.

In addition, Protestantism emphasized the supreme authority of the Bible in matters of faith, rejecting all that came from human tradition. This called into question many Catholic rites and beliefs — Marian devotions, for example.

Expanding quickly through northern Europe, the Reformation not only cleaved the church but changed the entire political spectrum of the continent before extending itself to North America. Catholic and Protestant princes clashed in conflicts that at times assumed the semblance of veritable wars of extermination. In France, Protestantism also became a political party with its own army and the support of some sectors

of the high nobility and princely class. Protestants were persecuted terribly, as evidenced by the Massacre of Saint Bartholomew. However, through the Edict of Nantes, Henry IV — a convert to Protestantism — imposed on Catholics and Protestants (not without some difficulty) a truly novel idea in Europe: religious tolerance. Louis XIV would later rescind the edict, but the idea had been successfully planted and survived.

And what about the Catholic Church? The alert call had been strident; the storm, violent; the ruins, many. A council was convened in Trent, a location chosen as a compromise — the population was Italian, but living on Germanic soil, at the feet of the Brenner Alps that separate Italy from Austria. Emperor Charles V, who was fighting off the assaults of the Turks, had even obtained the admission of Protestant delegations to the council's sessions. But this spirit of compromise did not last long. In the ensuing religious debates, each held to his position as being the absolute truth. The Catholic bishops promptly rallied together, most from southern Europe, as were their religious advisers, Dominicans and Jesuits (the latter called "rigorists" not without reason).

The work of the Council of Trent was immense. Countering Protestant positions, it professed that truth has two sources: Scriptures, to be sure, but also tradition, that is, that which Christians had said and believed since the first centuries. It reaffirmed the existence of original sin, which is remitted by baptism. It stressed that Christians can be saved through (good) works by the grace of God. It confirmed the effect of the sacraments, which is to confer this same grace upon those who receive them with the proper dispositions. It emphasized the essential role of the clergy, the importance of the ecclesiastical hierarchy, particularly the authority of the Roman pontiff. It proclaimed the legitimacy of the cult of the Virgin Mary and the saints. Finally, on the very day of its closure on December 15, 1563, it affirmed the existence of purgatory.

The majority of decrees issued by the Council of Trent were defined in opposition to Protestantism, often in abrupt terms. This, no doubt, kept the Catholic Church from better understanding the world that was emerging. Still, the decrees of the council sparked an outburst of pastoral and missionary zeal and brought about a reform of the church, including its hierarchy and the Roman Curia. Seminaries were created for the formation of the clergy, which until then had been barely educated, little disciplined,

and very loose in matters of moral observance. The catechism (first envisioned by Luther) also saw the light of day. Religious orders reorganized themselves while missionaries, accompanying navigators and explorers, brought the good news to the four corners of the globe. Most importantly, spirituality was again centered on Christ. The Catholic Church of our day is the same that was fashioned by the Council of Trent, at least in its essential structure and rites.

Even so, was it ready then to face the developments of subsequent centuries? Already at that time, civil states were claiming their autonomy. France, under the government of Richelieu—a Catholic cardinal—allied itself with Protestant nations against the powerful and Catholic imperial house of Austria. Thus, in the seventeenth, and even more so in the eighteenth century, the "Nation" triumphed over "Christendom," the state over the church. And ecclesiastical nationalism held sway as much in Germany as it did in the Austrian Empire.

Even greater difficulties were faced by the church in its confrontation with the rationalism of deism and the Enlightenment. While the church was expanding into the Americas, Africa, and—less successfully—into Asia, it was gradually receding in Europe. Philosophers and scientists challenged its doctrine—that is to say, its faith—and the people questioned the power it commanded. Decade upon decade, modern society grew more detached from Christianity.

The church did react, bringing its vitality to bear upon what was an unprecedented missionary expansion carried out in the nineteenth century and the first half of the twentieth. In Europe, the Catholic Church oscillated between two strategies: enclosing itself within its structures (Catholic schools, youth organizations, charitable institutions), and moving to regain the lost flock (priest-workers, Catholic action, and the "new evangelization," as coined by John Paul II). Continuing into the twentieth century, the Catholic Church launched into further exegetical reflection, both intellectual and theological, as demonstrated by the Second Vatican Council. It expressed its willingness to open itself to the modern world by accepting the secularization of society and emphasizing its own social aspects. It undertook many initiatives—not always very clear—aimed at drawing closer to other religions, starting with other Christian communities. In short, it no longer considered the values of the world as fundamentally harmful.

Yet, in our day, the Roman Catholic Church is questioning itself. The papacy of John Paul II, which contributed to the implosion of communism, shone with noted brilliance. However, recruitment of priests in developed countries is waning, which poses some delicate organizational difficulties. The multiple gestures of rapprochement toward other religions have not resulted in any real progress. Christians are persecuted, more or less openly, in many Muslim countries. Sects are growing, while the practice of the Catholic faith is shrinking. The church has not yet resolutely tackled the development of science and technology. In short, the church must take on new momentum; it must regenerate itself once again as it has been able to do across the centuries if it wishes to respond to its double mission: to nurture our hope for a better world here and another world beyond.

Jacques Duquesne

The Invention of the Universal

The transformation of the Gospel message into a worldwide church was the work of one man: Paul of Tarsus. A Jew of the Diaspora and a Roman citizen, at first he persecuted the new faith, and then converted to it on his way to Damascus when Jesus Christ appeared to him. Paul impressed upon the original apostles, who had been with Jesus in person, his universal (in Greek, *catholicos*) vision of the teachings of Christ. He was the first to seek to convert the pagans.

To be sure, there already were God-fearing people, such as the Roman centurion whose servant Jesus healed. However, while they recognized the God of Israel, they could not be fully integrated into the Jewish community, having to remain at the doors of the synagogue.

For Paul, adoption of the new faith did not necessitate observance of the Law of Moses, particularly with regard to the practice of circumcision and food prohibitions. This stance brought him into opposition with some of the apostles, including Peter, who was wary about breaking entirely away from Judaism. The first conflict was resolved around the year 50 at the first council of Jerusalem. Paul succeeded in winning the principal apostles over to his view, notably Peter, John, and James, but how the new principles were to be applied was unclear. Peter himself was loath to partake of the Gentiles' meals, for which he was reproached by Paul.

Paul's indefatigable proselytism would definitively settle the matter, for in a few years the mass of converted pagans surpassed the original community of Palestine, and the center of gravity of the new faith shifted from Jerusalem to Rome.

IL BASSANO
(*alias*, JACOPO DA
PONTE)
(1510/18–92)

*The Sermon of
Saint Paul*

Museo Civico,
Padua

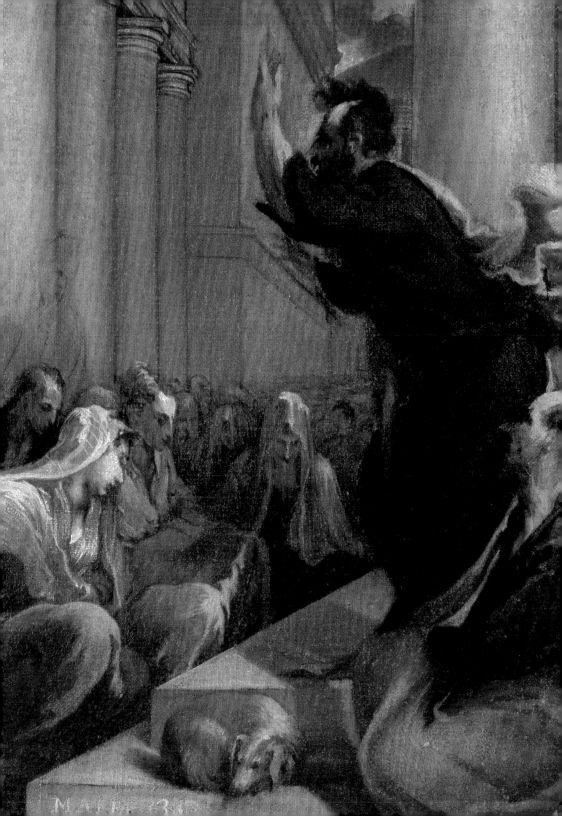

The First Pontiff

The history of the church began *de facto* in Rome, marked by the arrival of Peter and Paul in the capital of the Roman Empire, where they were martyred under Nero's reign.

We do not know the details of Peter's apostolate in Rome, but tradition has it that, kept in the Marmentine Prison, he converted his guards, Martinian and Processus, which enabled him to escape. But while fleeing Rome along the Appian Way, he came upon Christ.

"Quo vadis, Domine?" ("Where are you going, Lord?"), Peter asked him. A sweet and sad voice reached the ears of the apostle: "Seeing that you have abandoned my people, I am going to Rome to be crucified again." This is the high point of the novel *Quo Vadis?*, Polish author Henryk Sienkiewicz's masterpiece.

Peter retraced his steps, returning to Rome, where he was martyred. However, out of humility, so as not to die like Christ, he asked to be crucified head down. Similarly, his brother Andrew, another of the apostles, was martyred in Greece on an X-shaped cross.

CARAVAGGIO
(*alias,*
MICHELANGELO
MERISI)
(ca. 1571–1610)

*The Crucifixion of
Saint Peter*

Chiesa Santa Maria
del Popolo, Rome

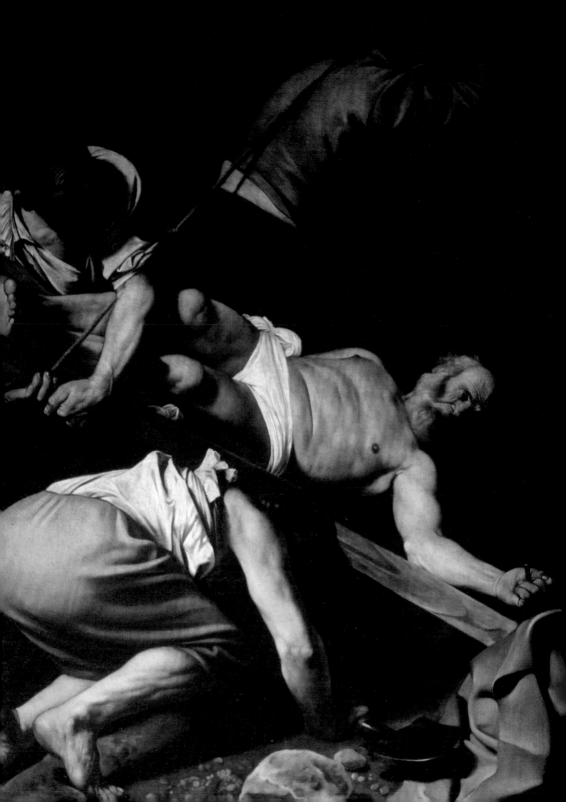

The Great Journey of the Saint Marys

In times gone by, when religious fervor did not reject, but was open to the marvelous and extraordinary, tradition complemented the Gospels with accounts of the great deeds of those who had walked with Christ. Thus, *The Golden Legend,* compiled in the thirteenth century by the archbishop of Genoa, Jacobus de Voragine, retraces the adventures of Martha and Mary and their brother Lazarus, brought back to life by the Savior.*

Pagan persecutors set them adrift on the Mediterranean — along with Saint Maximinus, Saint Fronto, Saint Trophimus, and two other Marys — in a small vessel with neither sail nor oar. Miraculously, they arrived at the coast of Provence at today's Saintes-Maries-de-la-Mer, and set about converting its people.

Tradition relates that Martha went to Avignon, and there delivered the town from a dragon called Tarasconus, at a site since then known as Tarascon. Mary Magdalene retired to a "frightful desert" on the cliffs of Sainte-Beaume where she led the solitary life of a hermit for 30 years. Maximinus, as bishop of Aix, received Saint Mary Magdalene's last breath in the village of Saint-Maximin.

Those early years of the church in Provence are reflected in the pilgrimages to Saintes-Maries-de-la-Mer, in the convent and cave at Sainte-Beaume, and in the Gothic basilica of Saint-Maximin. Having inspired many artists, they still have a marked presence in the area.

JOACHIM PATINIR
(ca. 1480–1524)

Mary Magdalen, Penitent [background: Pilgrims on the Way to Sainte-Beaume]

Musée des Beaux-Arts, Dijon

* In *The Golden Legend* and in some traditions, Mary the sister of Lazarus is also identified as Mary Magdalene. In Protestant and Greek Orthodox tradition, this is not the case; they are viewed as separate individuals.

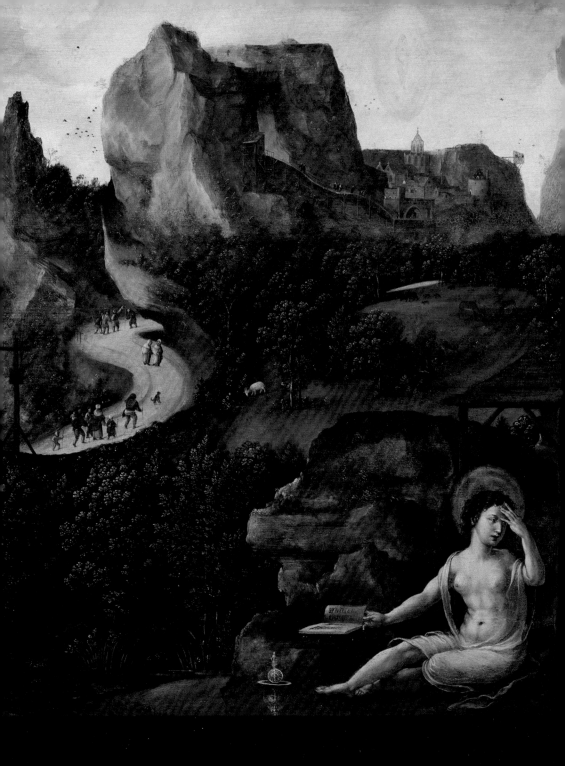

Emergence of the Great Symbols

First inspired by the Old and New Testaments, and then by the lives of the saints and events in the history of the church, traditional religious iconography has also been influenced by theological themes, in symbolism that can mystify both the irreligious and Christians themselves. This is particularly the case with the countless "vanities," paintings that wealthy penitents had in their oratories to help them meditate on the futility of the things of this world (all the while contemplating a work of art).

"Vanity of vanities, all is vanity" (in Latin, *vanitas vanitatum et omnia vanitas*), declares the biblical book Ecclesiastes. In order to illustrate this fragility of the joys of this earth, artists painted still life compositions juxtaposing symbols of worldly pleasures with signs of their illusory nature: gold coins, musical instruments, weapons, coats of arms, and culinary delicacies appear alongside grinning skulls, dust, and withered flowers. Sometimes children or cherubs are seen blowing soap bubbles, another symbol of the fragility of the things here below.

At times Vanity herself, a lovely nude woman accompanied by a peacock, admires herself in a mirror. At other times, a piece of cheese in various stages of decomposition suffices to illustrate the subject. Often, a maxim accompanies the painted theme, emphasizing the pedagogical nature of the painting: "Vanity," "Know thyself," or "Remember that thou shalt die."

PAUL CÉZANNE
(1839–1906)

Skull and Jug

Collection Peter
Nathan, Zurich

22

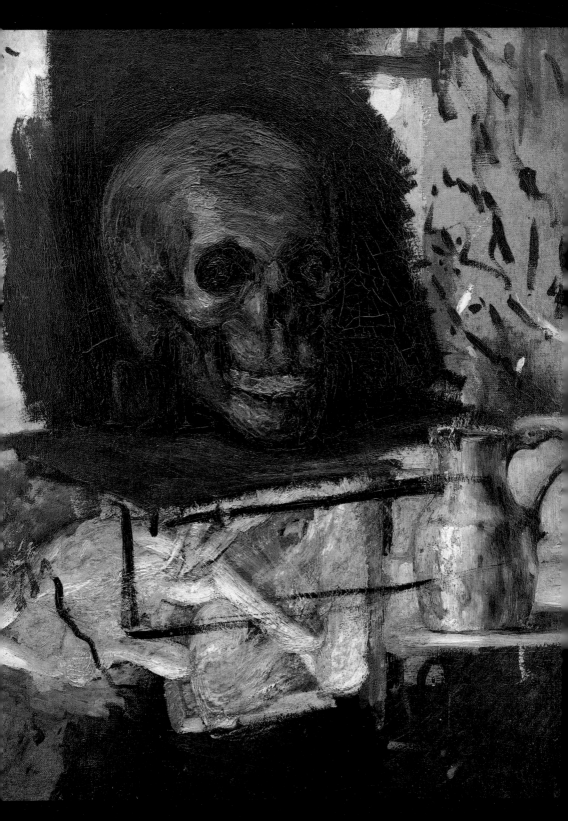

The Celebration of Baptism

At a very early stage, the church codified the sacraments indispensable for the faithful: baptism, confirmation, the Eucharist, confession, and extreme unction. To these are added two social sacraments reserved for certain people or certain circumstances: marriage and ordination of the clergy.

Following a variety of rituals (from a trickle of water poured on foreheads at the Catholic baptisteries to total immersion in other confessions), the sacrament of baptism makes obvious reference to Christ's baptism by John the Baptist.

Traditionally, in pre-Reformation churches, infants were baptized a few days after birth. After the Reformation, prompted by the refusal of Anabaptists to baptize the newborn, a substantial iconography emerged on the theme of Jesus blessing the children. Especially in Protestant countries, the intent was to substantiate the scriptural foundations of this sacrament.

Confirmation is received by Catholics apart from baptism, whereas in the Orthodox Church a person is confirmed immediately after having been baptized. This latter sacrament has received less attention from artists, though Nicolas Poussin dedicated two major works to it.

KONSTANTIN
KOROVIN
(1861–1939)

The Baptism

Tretyakov Gallery,
Moscow

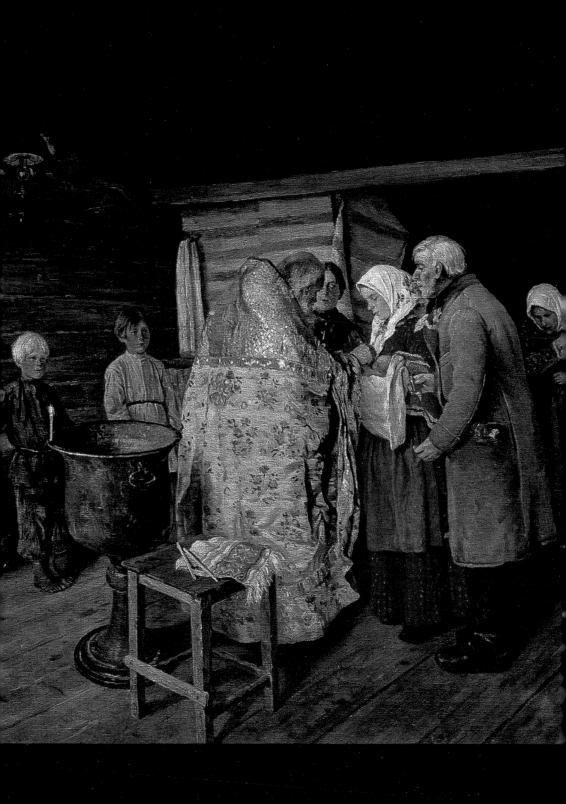

The Rise of Confession

It was with the Counter-Reformation that confessionals began to make their appearance in churches and then in religious paintings. Scenes of confession prior to this time demonstrate the doctrinal fluctuations affecting this sacrament, which was officially instituted in 1215 at the Lateran Council and given its classical form by the Council of Trent.

However, under the name of *penance,* the sacrament is much more ancient. The penance of Emperor Theodosius in 390 — who was barred from the church by Saint Ambrose until he had publicly shown his repentance — is a frequent theme in religious art.

Of all the sacraments, confession was the most polemical, a fact captured by Voltaire's quip that "Louis XI and the Marquise de Brinvilliers (who was executed as a poisoner) went to confession as soon as they committed a crime; and they confessed frequently, just as gluttons take medicine to increase their appetite."

GIUSEPPE MARIA
CRESPI
(1665–1747)

Confession

Gemäldegalerie
Alte Meister,
Dresden

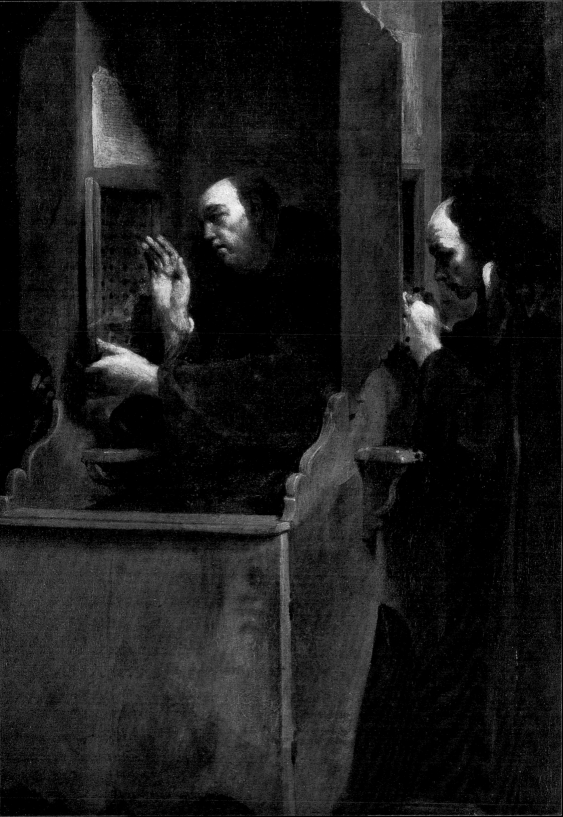

Penance and Flagellants

The notion of penance—inseparable from the sacrament of confession—has at times assumed disproportionate importance, leading to a veritable culture of mortification.

Mortification could be real or purely ostentatious, such as when Tartuffe enjoins his servant, "Laurent, put away my hair-shirt and my scourge."

Paintings of self-flagellation, which exist in great numbers, often illustrate famous penitents, such as King David, Mary Magdalene, and Saint Jerome. But they also portray processions of Spanish flagellants, or stray into bawdy sadomasochism, such as in Nicolas Lancret's painting where nuns scourge a young man under the pretext of illustrating La Fontaine's fable "The Spectacles."

No doubt, eroticism has always been a more or less discreet component of religious art, certain themes serving as excuses for many a scene of nudity. However, beginning in the eighteenth century, religious subjects were often used only to add flavor to compositions that were clearly of secular or profane inspiration.

FRANCISCO GOYA
(1746–1828)

*Procession of
Flagellants*

Museo Lázaro
Galdiano, Madrid

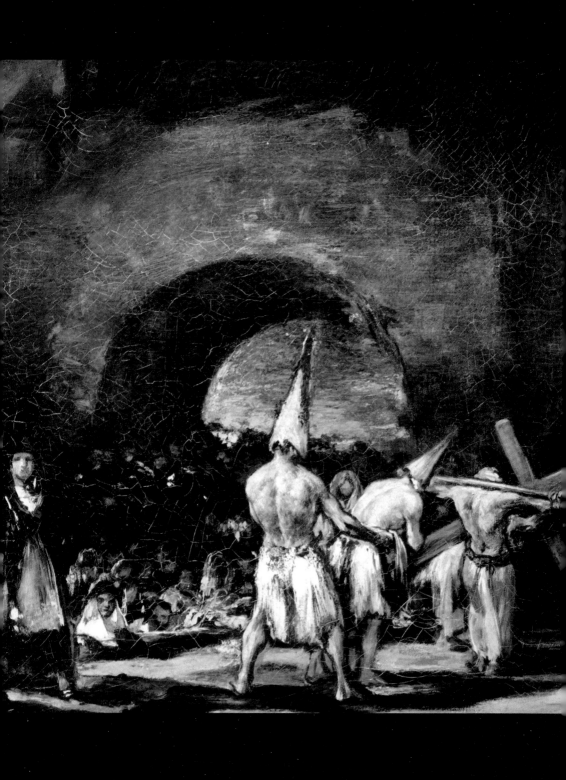

The Host

As the central sacrament of Christianity, the Eucharist is naturally a classic theme widely depicted in religious iconography. Besides count-less representations of the Last Supper — the blessing of the bread and wine on the occasion of Christ's last meal — particular stories of eminent figures receiving Communion have furnished artists with a multitude of subjects: Saint Teresa of Avila, Saint Lucy, Saint Jerome, Mary Magdalene, Bonaventure, Catherine of Siena, and so on.

The elevation of the host at Mass and the adoration of the Blessed Sacrament displayed in its monstrance have also been frequently rep-resented.

No less popular until the arrival of photography was a celebrated family theme: the First Communion of a child. This was always the occasion for a portrait of the first communicant, often surrounded by relatives. Accordingly, the Victor Hugo Museum has on display a painting of the First Communion of Leopoldine, the poet's daughter.

Francisco Goya
(1746–1838)

*The Last
Communion
of Saint Joseph
Calasanz*

Escuelas Pías de
San Antón, Madrid

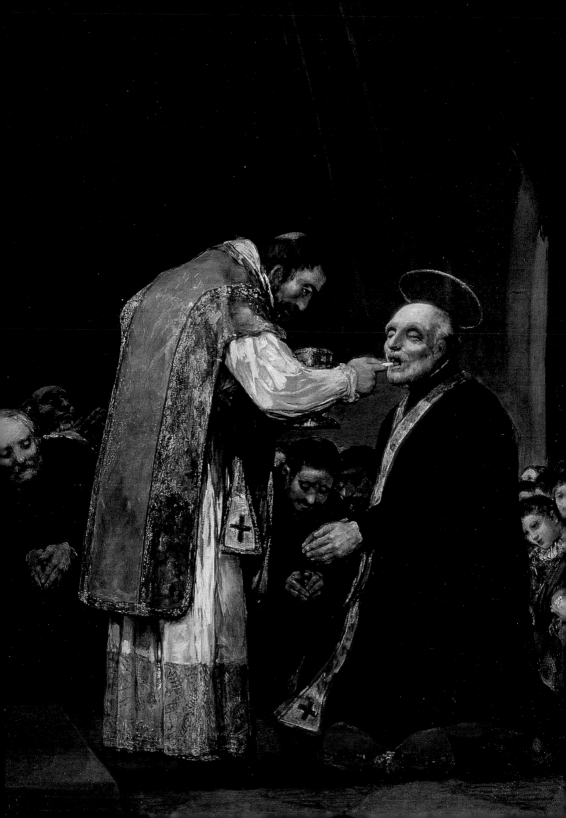

The Institution of the Viaticum

The last Communion of a dying person, the *viaticum*, administered jointly with confession and extreme unction if possible, is not obligatory. However, it is strongly recommended by the Catholic and Orthodox churches if circumstances permit.

Paintings illustrating the viaticum usually depict the exemplary last moments of a saint. The viaticum can also be seen in religious art "series" that picture all the sacraments, such as the canvases by Nicolas Poussin preserved in Grantham, England. These series include confirmation and ordination, themes that have inspired artists less frequently.

Works not directly related to religion, but simply representing the drama of the final moments before death, may also show the administration of the "anointing of the sick" with the oil used on these occasions.

AIMÉ PERRET
(1846–1927)

Holy Viaticum in Burgundy

Musée d'Orsay, Paris

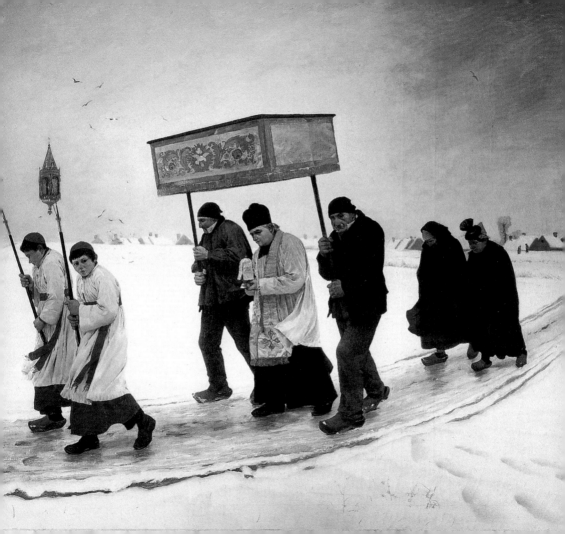

The Polemic over Purgatory

The gradual emergence of the dogma of purgatory triggered one of the most serious crises to have shaken the church. The dogma concerns the existence of an in-between state which is neither hell nor heaven, where sinners who do not merit going to hell endure a period of purification before attaining heaven.*

The concept of purgatory implies that the living can, in effect, influence the destiny of the dead, as outlined by the Council of Florence in 1439: "their souls are purified after death by the pains of purgatory, and for their release from these pains, the suffrages of the faithful who are alive are profitable to them; to wit, offering masses, prayers and alms, [and other works of piety]."

This led to the controversy over indulgences and eventually to Protestantism, which denies the existence of purgatory. In this context, the iconography of purgatory is often polemical, using imagery to evince its reality and, in a certain way, trace its mode of operation. What is portrayed is a place of torment that, unlike hell, is not closed. The Blessed Virgin or the archangel Gabriel often appears, coming to release the souls and lead them into heaven.

Another source of inspiration for artists was found in Dante's *Divine Comedy,* which offered them an extraordinary description of purgatory (where the poet placed certain popes not of his liking). Such is the success of this literary work that it has been illustrated by countless artists throughout history, from medieval illuminators up to Delacroix and Manet.

DOMENICO DI
MICHELINO
(1417–1491)

*Dante and the
Divine Comedy*

Cathedral of Santa
Maria del Fiore,
Florence

* Some notion of a state of purgation for the dead, and the possibility of the living helping them by their prayers and offerings, has existed in one form or another over time. Plato spoke of a lake where the dead were to atone for their faults. In Jewish tradition, helping the deceased by suffrages is explicitly alluded to in 2 Macc 12:44–45, and the custom of praying for the departed is retained by Orthodox Jews to this day. This belief and practice continued among early Christians, with inscriptions in the catacombs giving evidence of prayers for the deceased and the fathers of the church expounding on the matter in their writings, most notably, St. Augustine of Hippo. — *Trans.*

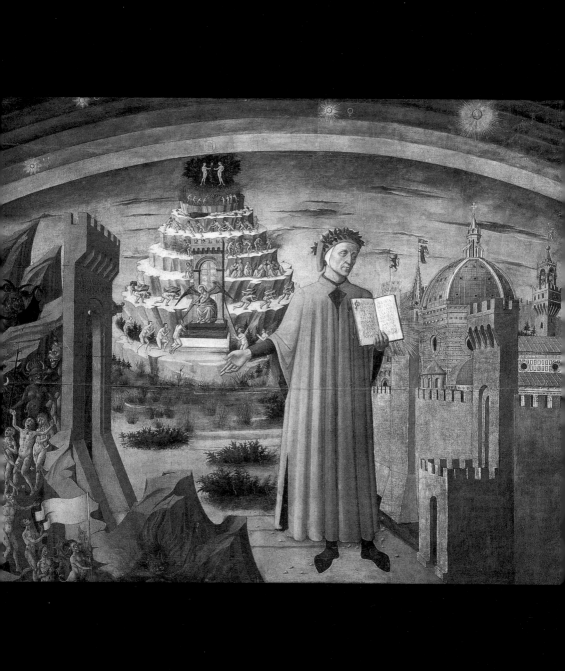

Emergence of the Virtues

"What Greek Antiquity did for the Muses, the Christian seventeenth century did for things spiritual, with yet greater finesse; it invented a Parnassus where, like beautiful maidens, the categories of the ideal hold court."

This comment on the "Christian Muses" by the academician and art historian Louis Gillet refers to the virtues, which had already been systematized by Saint Thomas Aquinas in the thirteenth century. There are three theological virtues — faith, hope, and charity — and four cardinal virtues — prudence, justice, fortitude, and temperance. As they do not readily lend themselves to being illustrated, it took great ingenuity on the part of artists for the virtues to take on flesh. They mostly had recourse to allegories.

Often assigned to ceilings, illustrations of the faith usually rely on an aggregation of symbols set amid ethereal ornamentation: the cross, angels, the Holy Spirit depicted as a dove, etc. The Virgin Mary is represented more frequently than Christ, since it takes a woman to personify a muse.

Other artists have shown manifestations of the faith through simple and touching scenes. In this case too, devotion to the mother of Christ is most prominent.

MAURICE
BOMPARD
(1857–1935)

Prayer to the Madonna

Musée d'Orsay, Paris

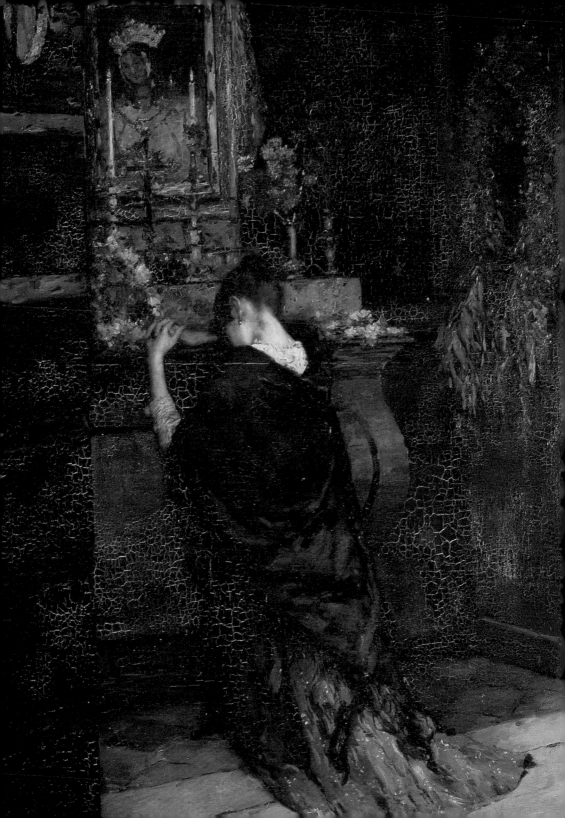

A Celebration of Charity

The virtue of charity is more easily illustrated than the virtue of hope, which is an internal and intimate sentiment. In addition to allegorical and symbolical representations, a number of paintings celebrate charity by providing examples of the virtue expressed in deeds. In this category, there are two themes that vie for popularity: the Good Samaritan nursing the victim of brigands, and Saint Martin of Tours cutting his mantle in two to share it with a beggar.

The distribution of alms, visits to the sick or to prisoners, the care of victims of the plague, in short, all manifestations of selflessness have been represented in art, at times portraying well-known personages and at others, anonymous figures.

The importance of these themes is reflected in the "acts," prayers that every Christian should recite regularly — besides the act of contrition, there is an act of faith, an act of hope, and an act of charity.

Lucas Cranach
(1472–1553)

Charity

The Schloss
Museum, Weimar

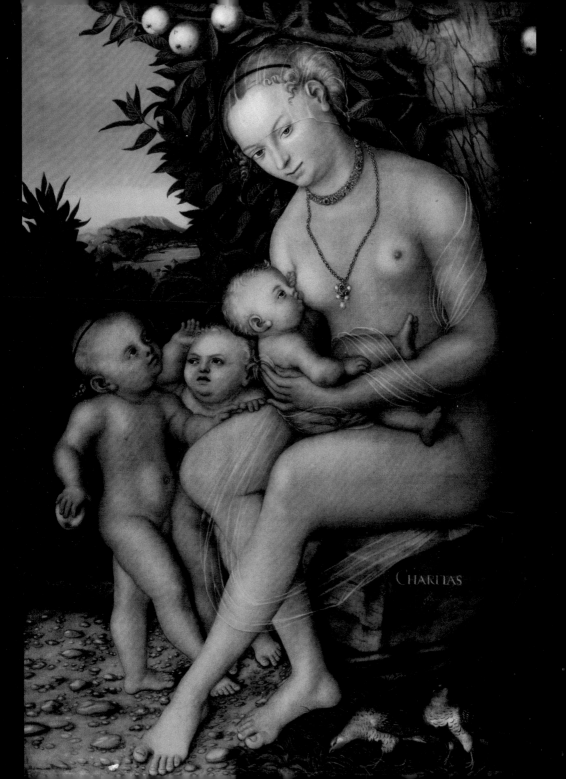

CHARITAS

Very Attractive Sins

The seven capital sins — pride, greed, lust, envy, gluttony, anger, and sloth — constitute an inexhaustible source of inspiration for artists.

It goes without saying that a theme such as lust is quite popular among artists; but gluttony and sloth have also lured their interest. However, their intent has not always been clear. Are these works religious illustrations properly speaking, or a call to civility, or are they perhaps a discreet celebration of pleasurable vices? Representations of greed, on the other hand, are usually redolent of a humor more or less dark.

There is no ambiguity, however, in the frescoes of the Plampinet chapel, in the Hautes-Alpes in France: sloth is represented by an ass; anger, by a leopard; gluttony, by a wolf; lust, by a goat; pride, by a lion; and greed, by a badger; and all seven are being driven by the devil into the jaws of hell.

The seven capital sins are one of the rare religious subjects that still draw the interest of artists in our day. James Ensor, Otto Dix, and Bernard Buffet have each created a series of works illustrating the theme.

HIERONYMUS
BOSCH
(ca. 1450–1516)

*The Seven Capital
Sins*

Museo del Prado,
Madrid

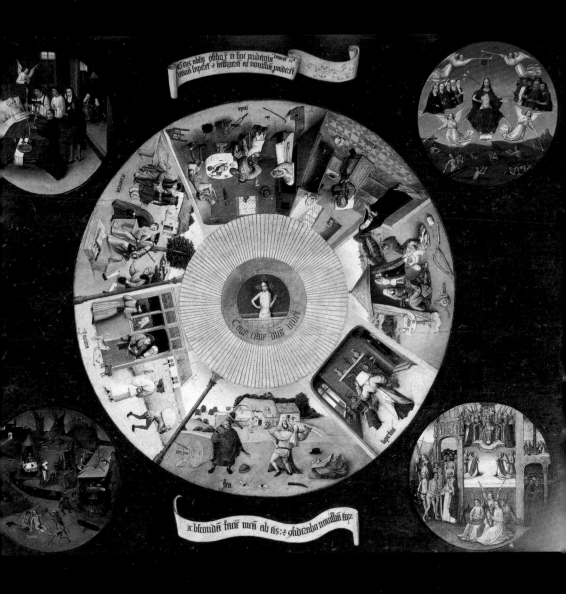

The Thousand Faces of Temptation

The existence of sin presupposes the existence of a tempter — Satan, so frequently portrayed in the midst of his malefic operations. The Bible supplies its illustrators with two great stories of temptation: the serpent persuading Adam and Eve to taste the fruit from the tree of knowledge, and the devil importuning Christ after his 40-day fast in the desert.

But there is another temptation that has enjoyed widespread notoriety and inflamed the imagination of countless artists: the temptation of Saint Antony, who died in 356. Living as a hermit in the desert from 20 to 105 years of age, he was constantly harassed by a demon who, gifted with an overflowing imagination, devised an infinite number of guises to seduce and deceive his victim.

Artists — particularly painters, from Hieronymus Bosch to Salvador Dalí — have employed veritable treasures of ingenuity to depict these multiform temptations. Authors likewise have contributed their talents, such as Gustave Flaubert, who took 30 years to finish his *Temptation of Saint Antony,* described by his contemporary Barbey d'Aurevilly as "a nightmare traced with a splendid brush dipped in the colors of a rainbow."

It should be noted that Flaubert added an eighth capital sin to the list, even worse than the original seven: logic.

JOACHIM PATINIR
(1480–1524)

*The Temptation of
Saint Antony*

Museo del Prado,
Madrid

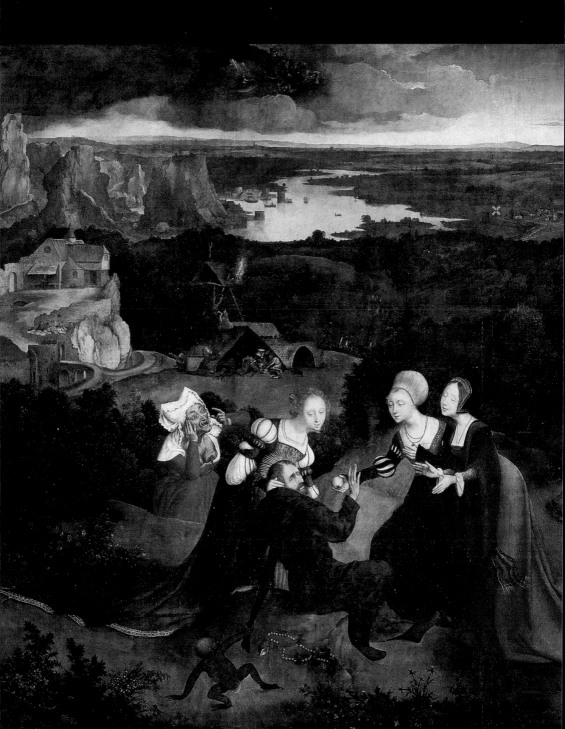

The Period of the Hermits

"At that time, the desert was populated by anchorites." This slightly ironic remark by Anatole France describes a reality of the beginnings of Christianity. Following the example of Christ, who would withdraw into the desert to pray, the first Christians, prompted by their religious fervor, took to the arid solitudes east of the Jordan or the deserts of Egypt, particularly in the environs of the city of Thebes, where they formed their communities, the thebaides.

Many exemplary figures, such as Saint Antony and Saint Jerome, chose this path, and it was said that even the devil himself ended following the same way: "The devil was very elderly when he became a hermit," quips Alfred de Musset.

The eremitical life was not restricted to men. Holy women who lived in solitude were likewise offered as examples to edify the faithful. The first of these was Mary Magdalene, who, tradition has it, retired to a cave in Provence, France. But another Mary was equally popular — Mary of Egypt, a prostitute of Alexandria who converted during a pilgrimage to Jerusalem and spent 27 years in the Jordan desert.

From being the theme of sermons, hermits naturally passed on to adorning church frescoes, and then to the artist's canvas.

JUSEPE DE RIBERA
(1591–1652)

Mary of Egypt

Museo del Prado,
Madrid

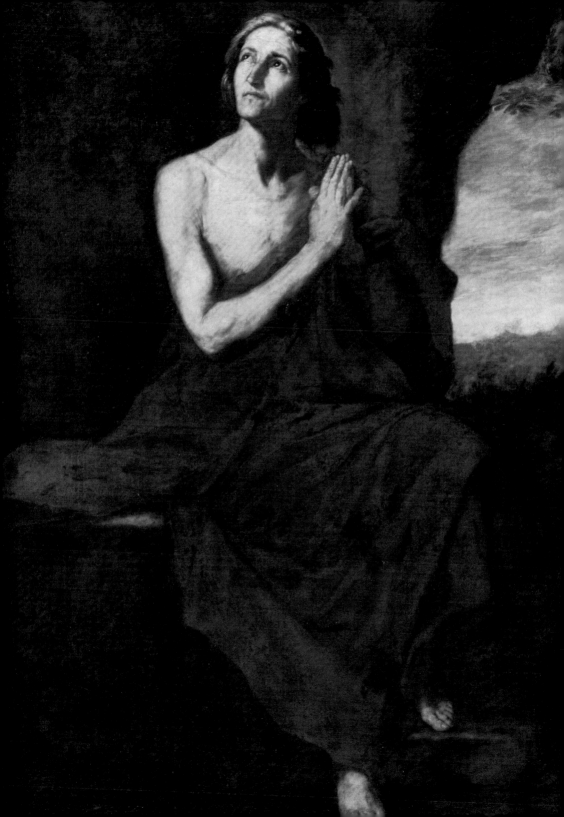

The Flourishing of Monasteries

As the persecution of Christians by the Roman Empire ceased, hermits increasingly began to congregate into groups to lead a communal life. The first monastery in Gaul was erected toward the year 240, on the isle of Barbe in Lyons. In the fourth century, Saint Pachomius in Egypt wrote the first monastic rule, while Saint John Cassian introduced this form of religious life to Provence, France, with the creation of the abbey of Saint-Victor in Marseilles. In 530, Saint Benedict established a monastery in Italy for which he drew up a rule of life that gave rise to a number of monastic orders.

How this movement thrived and spread can easily be demonstrated: at the beginning of the fifteenth century, there were records of some 15,000 abbeys founded in France! Some of them did not last long, while others still stand.

Such a movement could not be ignored by religious iconography, which has paid homage to the great founders of monastic orders.

JÖRG BREU, THE
ELDER
(1475–1537)

*Saint Bernard
Praying for the
Harvest*

Church of Zwettle,
Austria

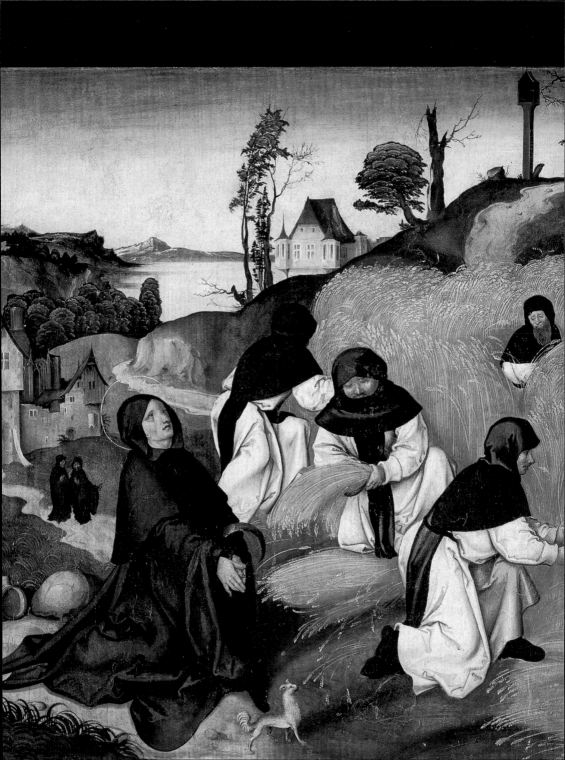

Three Centuries of Persecution

Whether considered anarchists, enemies of humankind, or simply bad citizens because they refused to sacrifice to the gods of the communities where they lived, the first Christians suffered through three centuries of ferocious persecution, interspersed with periods of respite.

Most often they were only condemned (to death or to forced labor in mines) after repeatedly refusing to sacrifice to idols, and, most importantly, to the emperor, considered a demi-god. Out of fear of torture, many naturally succumbed to apostasy, but often repented later on.

This tragic situation occasioned the first notable schism in the nascent church. At the end of the fourth century, a portion of the clergy and Christian community refused to accept the reintegration of the *lapsi* ("those who have fallen," as the apostates were called), readmitted by the pope.

This donatistic heresy—after the African bishop Donatus, apostle of intransigence—led to renewed persecutions at the very time when the promulgation of the Edict of Milan, in 313, by Emperor Constantine, should have brought about conciliation. Thenceforth, it would be Christians themselves persecuting Christians.

Of course, artists preferred to celebrate the countless "witnesses" (the translation of the Greek word *martyr*) whose love for Christ was such as to bring them to partake in his sufferings.

ALBRECHT DÜRER
(1471–1528)

*The Martyrdom
of Ten Thousand
Christians*

Kunsthistorisches
Museum, Vienna

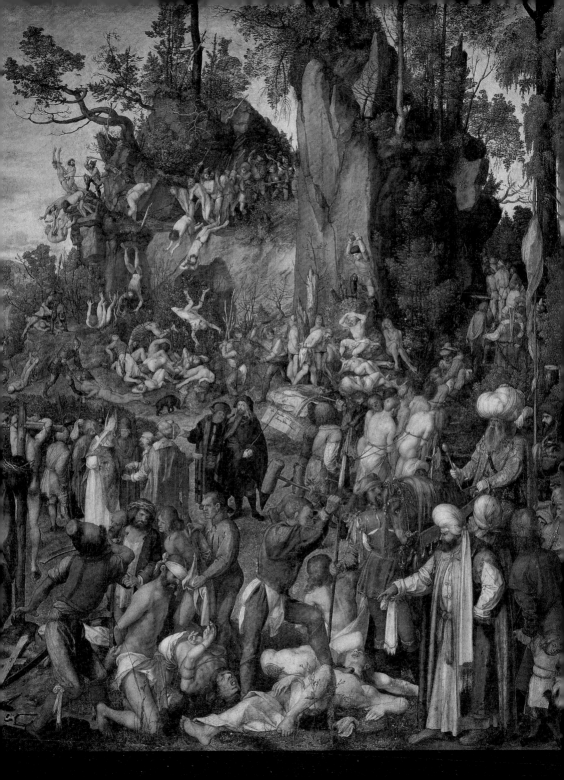

The First Popes

In the two and a half centuries of persecution during which the church had to remain underground, about 30 pontiffs succeeded each other to the throne of Peter. Their history is often obscure; already some antipopes appear among them, playing a prominent role at times. This was the case, for example, with Hippolytus, in the third century, who opposed himself to three successive popes: Calixtus, Urban, and Pontian. In the end, he was reconciled to the official church and suffered martyrdom in Sardinia, which makes Hippolytus the only antipope ever to be canonized!

The difficulties of their time did not keep most of the early popes from engaging in intense pastoral activity and, above all, from fighting numerous heresies. At the end of the second century, Eleutherius even organized overseas missions, sending priests to convert the pagans of Britain.

Most of the early pontiffs died as martyrs; all of them have been canonized.

MASOLINO DA PANICALE (*alias,* TOMMASO DI CRISTOFORO FINI) (1383–ca. 1447)

Pope Liberius Lays the Foundation of the Basilica of Saint Mary Major

Galleria Nazionale di Capodimonte, Naples

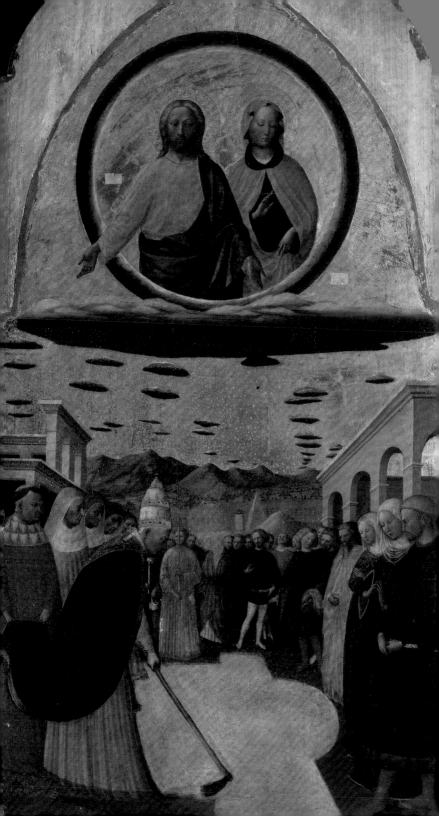

The Spread of Christianity

The apostles first evangelized their immediate surroundings, an effort that soon came to encompass the entire Roman Empire. By the end of the second century, the new faith had spread from Arabia to Mauritania, and from Egypt to Caledonia (Scotland).

Christianity then rapidly spilled over to the frontiers of the known world. The apostle Andrew was crucified in Scythia; Simon and Jude suffered the same martyrdom in Persia; Thomas ended his days evangelizing India; and Bartholomew was skinned alive in Armenia.

Special mention should be made of two far removed countries that have preserved their faith as originally received. Abyssinia was evangelized very early — the Acts of the Apostles mentions the conversion, by the deacon Philip, of the Ethiopian who read the Scriptures in his chariot. And Armenia has held Christianity as its official religion for 17 centuries, ever since the baptism of its king Tiridates III by Saint Gregory the Illuminator in 301.

Francesco Zugno
(1709–1787)

*Gregory the
Illuminator
Baptizing the King
of the Armenians*

San Lazzaro degli
Armeni, Venice

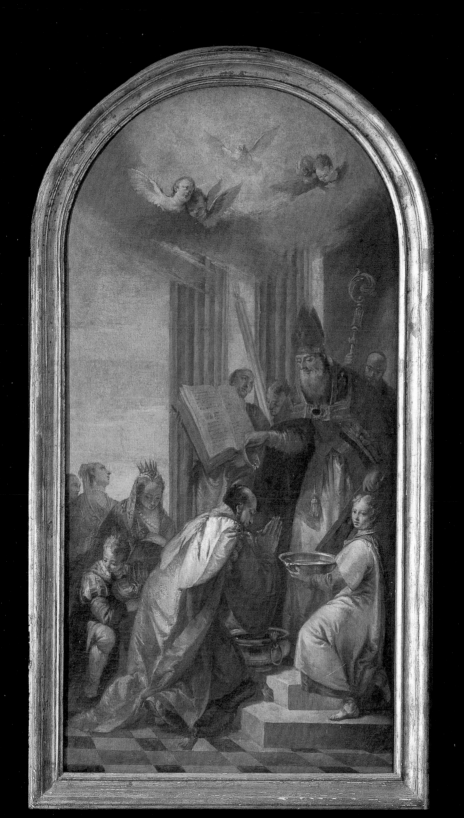

The Donation of Constantine

In 335, after founding his capital of Constantinople, Emperor Constantine came to Rome to be baptized by Pope Sylvester I. As a sign of submission, he accorded to the sovereign pontiff both the Lateran palace and the insignia of dominion over the Western Empire.

Little does it matter that the emperor was never actually baptized and that he bequeathed the entire empire to his own sons. Throughout centuries, this charming legend buttressed the claims of the papacy to temporal power, provoking no end of conflicts between the pope and the rulers of Western Europe, particularly the Italian princes, the French kings, and the Germanic emperors. Still, basing his action on that gift, Pope Alexander VI, in 1493, divided the New World — yet in the course of being discovered — between Spain and Portugal.

Illustrations of this controversial story are by necessity polemical, so it is no wonder that they are found primarily in Rome.

There is another donation that seems to be historically linked to Constantine's. In 754, Pepin the Short granted to Pope Stephen sovereignty over Corsica and over the Italian towns he had conquered from the Lombards. In return, the pope consecrated Pepin as king of France, thus establishing the Carolingian dynasty, which replaced the Merovingian kings.

Anonymous
FRESCO
(1246)

The Donation of Constantine

Basilica of the
Santi Quattro
Coronati, Rome

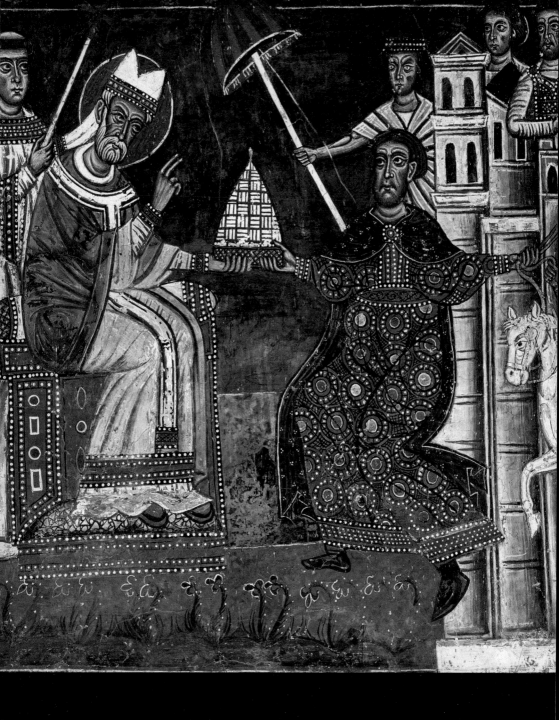

The First Conflicts, the First Councils

Even before his controversial conversion, Emperor Constantine called the first ecumenical council to bring an end to the theological quarrels that were dividing the nascent church. These religious differences threatened the unity of the empire.

This first council, convened in Nicæa in 325, settled the matter in favor of the divinity of Christ, as upheld by Rome, against the Arian heresy. One century later, the Council of Chalcedon (451) would extend the condemnation of Arianism to Nestorianism and the Monophysitism of the Egyptian church.

The Symbol of Nicæa-Constantinople, composed by the first council and completed at the Council of Constantinople in 381, encapsulates the essentials of the Christian message. It is more commonly known as the *Credo* or Creed. However, the Latin Church later added a detail by which the Holy Spirit proceeds from the Father *and* the Son. This occasioned the dispute over the *filioque* ("and the son" in Latin) which eventually led to the Great Schism between Rome and the Orthodox world. As a note of interest, John Paul II, when reciting the Creed, would often omit the formula *filioque*.

This point of difference regarding the nature of the Holy Spirit is reflected in the way the Trinity is portrayed in Catholic paintings and in Orthodox icons.

ANDREA DEL
SARTO
(1486–1530)

*Discussion about
the Trinity*

Palazzo Pitti,
Florence

The Christianization of Gaul

Christianity arrived in Provence in the earliest days of the church, and rapidly proceeded to spread to the north of France, as records of the persecution of Christians there attest. In 177, a young slave-girl by the name of Blandina was successively exposed to wild beasts, burnt live on a grill, and lastly, tied up in a net and thrown to a ravenous bull that finally killed her. Blandina is the patron saint of the city of Lyons.

The broader expansion of Christianity within France, including the rural areas which lagged behind in paganism, was the work of an officer of the imperial army from Pannoia (ancient Hungary) by the name of Saint Martin, and was launched by his giving half of his mantle to a beggar. Because a member of the Roman army paid for half of his equipment, he felt he had the right to dispose of his own portion in this way.

After he was baptized and ordained a priest, Saint Martin founded his first monastery in Ligugé, south of Poitiers. It was from there that the people of Tours took him away and made him their bishop in 371. His activities subsequently spread throughout all of Gaul, evidenced by the many churches and towns that bear his name.

It so happens that these "Saint-Martin" places sit upon the ancient Fields of Mars where the Roman armies used to encamp, an association that fits perfectly well with a military saint.

ANTHONY VAN
DYCK
(1599–1641)

*Saint Martin
Shares His Mantle*

Saint Martin
Church, Zaventem,
Belgium

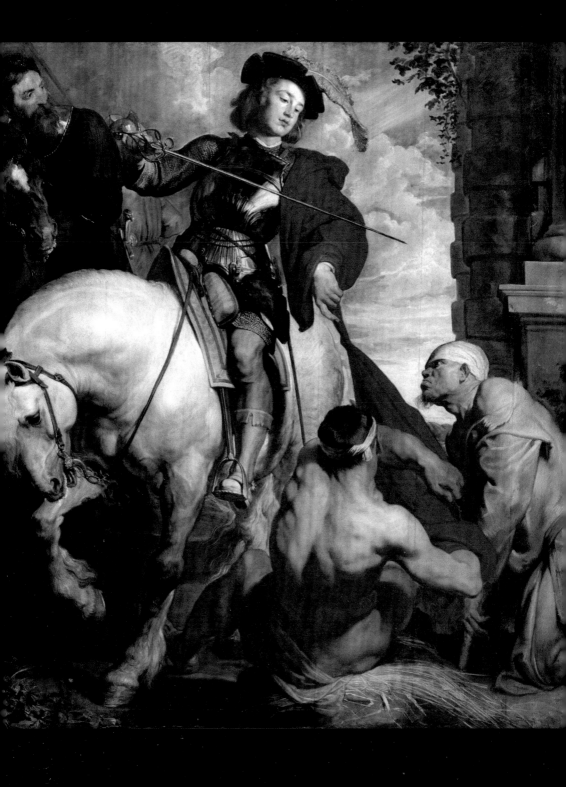

Fathers and Doctors

Pastoral concerns and the need to fight against heresies generated intense intellectual activity in the first centuries of the church. A multitude of theoretical and polemical writings (the latter against pagans as well as against believers who were deemed heretical) rapidly emerged, producing the doctrinal corpus of the new religion. The principal contributors to this body were Irenaeus of Lyons, Clement of Alexandria, Origen, Tertullian, Lactantius, Eusebius of Cæsarea, Athanasius, Gregory Nazianzen and Gregory of Nyssa, John Chrysostom (John "Golden Mouth"), Ambrose, Jerome, and Augustine.

Not all of them professed beliefs that were in line with the canons finally established by the church. For example, Origen castrated himself to eschew temptation, and Tertullian succumbed to Montanism. As a result, a distinction among the early authors is made between the fathers and the doctors of the church. The former are recognized as having played an important historical role, while to the latter is attributed the richness of true doctrine. The Catholic Church recognizes 33 such doctors, the last being Saint Thérèse of Lisieux, proclaimed a doctor in 1997.

This distinction is also reflected in religious art. The fathers are rarely represented, while the doctors have inspired abundant iconography.

ATTRIBUTED TO
JAN VAN SCOREL
(1495–1562)

*The Baptism of
Saint Augustine*

Church of Saint
Stephen, Jerusalem

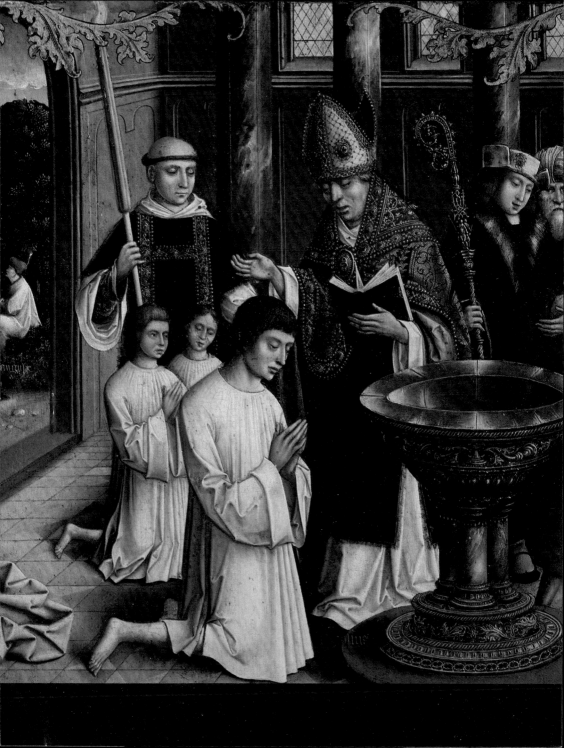

The Lion and the Vulgate

Three symbols appear frequently in illustrations of Saint Jerome (342–420): a Bible, a lion, and the cardinal's hat. The latter signifies Jerome's illustriousness and the authority that the magisterium recognizes in him. The lion refers to an anecdote related in *The Golden Legend,* which lends a more human face to this intellectual figure. During his many years at a monastery in Bethlehem, Saint Jerome once helped a lion by pulling a thorn from its paw. The lion, tamed as a result, was appointed the caretaker of the convent's donkey, daily conducting it to its pasture. One day, the donkey disappeared, and the lion was condemned to carrying out the duties of the beast of burden. The lion bore its punishment with admirable stoicism, until the robbers who had stolen the donkey returned it to its rightful owners.

The Golden Legend is less attentive to describing Saint Jerome's true merit. This polyglot from Pannoia translated the Bible into Latin — translating directly from the Hebrew those books originally written in that language (while referring also to the Greek translations of the Septuagint) and translating the other books from Greek.

His translation still is recognized by the Catholic Church, though it is known that Saint Jerome at times did not shy from adding some original text. For example, in the book of Tobit, where an angel requires that Tobiah recite a prayer before consummating his marriage, Jerome's translation has this prayer lasting three days, a detail that demonstrates the importance the holy translator attached to continence.

DIERIC BOUTS
(ca. 1415–75)

Saint Jerome

Church of Saint Peter, Louvain

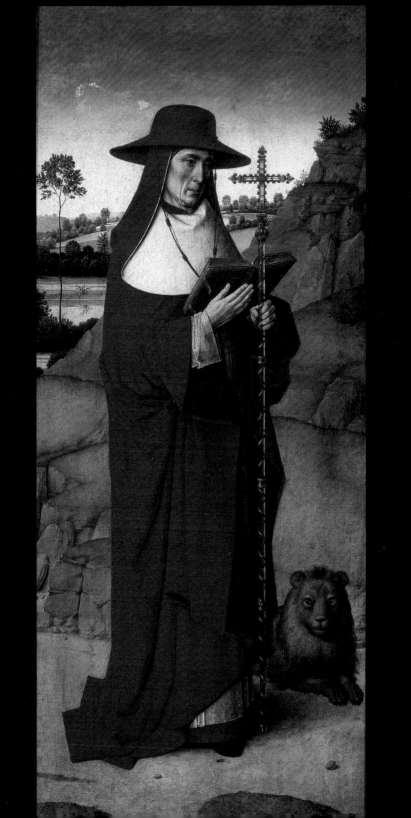

The Baptism of Clovis

From his ascent to the throne at age 15, Clovis—a minor king of a Salian Frankish tribe occupying a small area of Belgium—proved to be a redoubtable strategist. By the age of 20 he had already extended his realm to the Loire River in France, and had grasped the fact that the church was the only standing structure in a Gaul that was falling apart. He also married Clotilde, a Catholic princess.

At the battle of Tolbiac, against the Alemanni of Cologne, he proffered his famous prayer: "O God of Clotilde, should you give me the victory, I will be baptized." Forthwith, the king of the Alemanni fell by the blow of an axe. Clovis kept his promise and was baptized shortly afterwards in Rheims by its bishop, Saint Remigius.

At that time, the vast majority of barbarian tribes who had come into contact with the new faith had embraced Arianism, while the old lands of the empire were still faithful to the Roman Church. Thus, the clergy of Gaul became Clovis's sure and decisive support. He invaded Armorica and Burgundy and in 507 conquered Aquitania from the Arian Visigoths under King Alaric II.

Subsequently named a consul of the Romans, Clovis established his capital in Paris, at the center of an area that came to be known as "Little France" (*Little* or *Luddle Francq* in the Frankish language), whence came "Ile-de-France."

Henceforth, the Catholic Church and the French monarchy would be allied partners.

GIUSEPPE
BEZZUOLI
(1784–1855)

*The Baptism of
Clovis*

Chiesa di San
Remigio, Florence

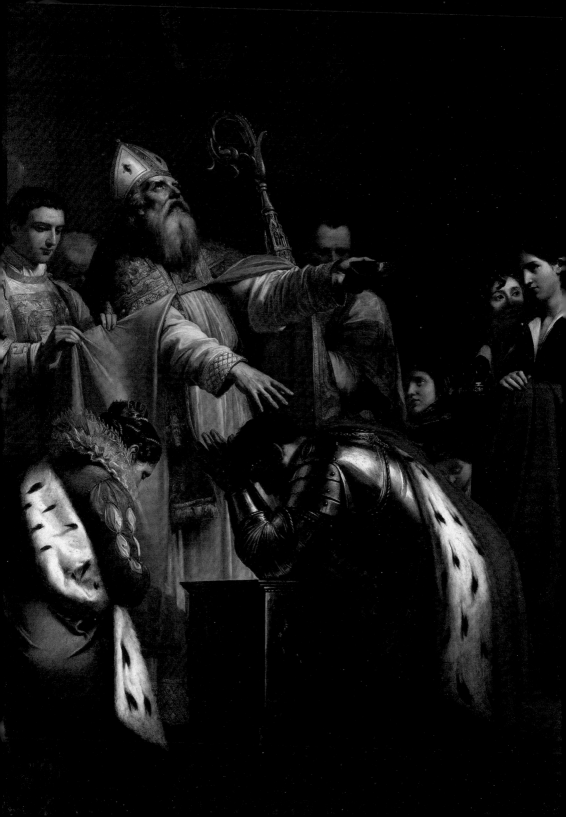

The First Great Pope

The definitive reconciliation of the church with civil society can be dated to the rise of Gregory I to the papal throne. Until then, the young religion was still imbued with the nonconformist spirit typical of those who oppose themselves to the establishment — political, economic, and cultural.

A scion of the high Roman aristocracy, Gregory first pursued a political career that could be described as classic, except that he was as honest as he was efficient. A fervent Christian, he placed his fortune and his spirit of initiative at the service of the faith.

One day, passing by the slave market, he noted some blonde children and asked who they might be. At the reply "Angles," he remarked, "They aren't angles, but angels" [Non sunt angli, sed angeli]. Once he had become pope, he himself organized a missionary expedition to distant England, in French, *Angleterre*.

The people of Rome elected him to the throne of Peter in 590, against his will and despite his fortune. (As *The Golden Legend* points out, "It isn't wealth, but covetousness, that makes a man rich.") Just as he had formerly brought order to the administration of the city, he launched a reform of the church, exacting strict discipline from the clergy, regularizing the liturgy (the Gregorian Rite), and founding a school of music that promoted Gregorian chant, which no doubt had its origin in the hymns of Greek mystery plays.

The Gregorian calendar came much later, the work of Pope Gregory XIII in 1582.

CARLO SARACENI
(1579–1620)

Saint Gregory the Great

Palazzo Barberini, Rome

The Arrival of Islam

In 732, exactly one century after the death of Mohammed, Charles Martel halted a Muslim raid between Poitiers and Tours. The spectacular speed with which the Arabs carried out their conquests was a phenomenon. After having seized Egypt and the Christian Africa of Saint Augustine and quickly reinforced by Berber tribes converted to Islam, the horsemen of Arabia passed into Spain in 711. The Iberian Peninsula was covered by Islam, with the exception of a few valleys in the north. A practical outcome of the Muslim victory over the Arian Visigoths of Spain was that it sealed the fate of the Arian heresy.

Muslim expansion continued beyond the Pyrenees into France, and Narbonne also fell. To the East, Constantinople was twice under siege (in 673 and 717), but each time narrowly succeeded in destroying the Muslim fleets, thanks to the Byzantines' Greek fire, which could burn even on water.

The Catholic response was also swift. In 778, Charlemagne made some incursions into Spain. And the small Christian principalities of the north gradually extended further into the peninsula, invoking the name of Saint James of Compostela, *Santiago Matamoros*, the "slayer of Moors."

These conflicts, however, did not keep Charlemagne from establishing diplomatic relations with the caliph of Baghdad, Harun al-Rachid, who presented him with the gift of an elephant in 801.

Nonetheless, the Mediterranean Sea, the *mare nostrum* [our sea] of the Roman Empire, ceased to be a zone of exchange and symbol of unity, instead becoming the frontier of hostilities between two civilizations violently at odds with each other.

Juan Carreño de Miranda
(1614–1685)

Saint James Leads the Spaniards against the Moors (Battle of Clavigo, 834)

Szépmûvészeti Múzeum, Budapest

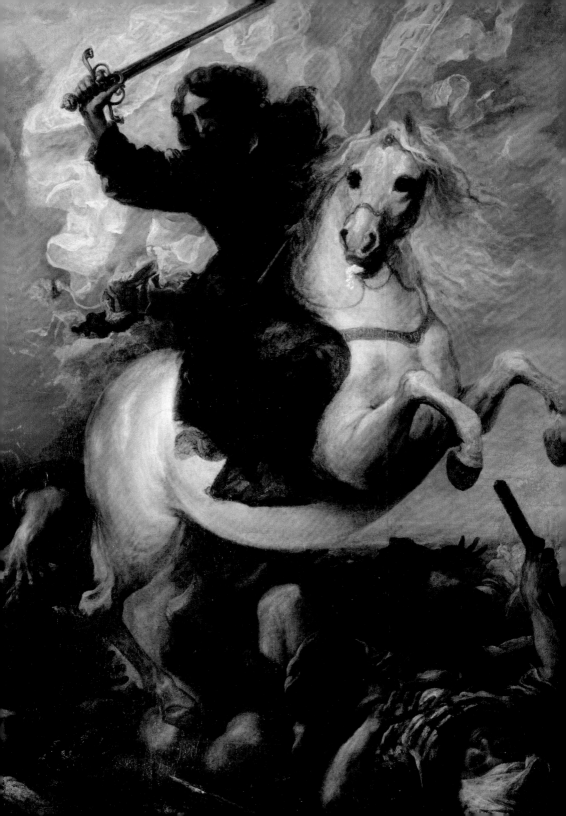

The Conversion of the Saxons

Charlemagne, the son of Pepin the Short and grandson of Charles Martel, continued the bold policies of his dynasty, blocking Muslim expansion in the south, but also marching into the East, in the direction of the Saxon world.

In 772, he destroyed the Irminsul, the "world-tree" of the Germanic pagans, along with the sanctuary where it stood in the forest of Teutoburg — an event of symbolic significance. The conversion of the Saxons thus proceeded, unhampered by useless subtleties: the choice was baptism or death. At Verdun in 782, Charlemagne had 4,500 rebellious Saxons killed in one day, and to bring an end to the incessant uprisings, the emperor deported massive segments of the population.

At the same time, the first Saxon bishoprics were created in Bremen and Munster, and Germania was soon covered with a network of garrisons and monasteries.

Fashioning himself the champion of the Roman Church, Charlemagne naturally had himself crowned emperor by Pope Leo III in 800. Thus was the Frankish monarchy grafted into the ancient Western Roman Empire, bringing it back to life after 325 years of dormancy.

HERMANN
WISLICENUS
(1825–99)

*Charlemagne
Has the Irminsul
Destroyed*

Fresco at the
Kaiserpfalz
(Imperial Palace),
Goslar, Lower
Saxony

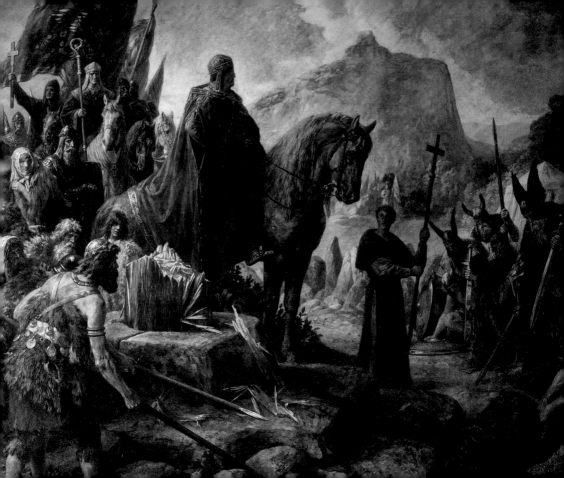

The Conversion of the Slavic World

The effort to evangelize the pagans of northern Europe in the ninth century was double-pronged. While Charlemagne marched from the West into Saxon territory, a missionary movement from Byzantium penetrated the Slavic world. In 863, Photios, patriarch of Constantinople, sent two brothers, Cyril and Methodius, to Moravia. The Slavic rulers, uneasy with the expansion of the Franks, seized the opportunity to align themselves with a competing Christian pole. Basing their work on the Greek alphabet, Cyril and Methodius invented the Cyrillic, or Glagolitic, alphabet in order to translate the Scriptures and the liturgy into the Slavic tongue.

These competing avenues of evangelization were not accidental, but a reasoned concurrence. Pope Hadrian II formally patronized the mission of the two brothers, and his successor, Nicholas I, approved their translation of the liturgy. In fact, Cyril died in Rome in 869, and in 1980, John Paul II proclaimed him and Methodius patron saints of Europe.

The second phase of the conversion of the Slavs came one century later, when Vladimir, prince of Kiev, wed Princess Anne, sister of the Byzantine emperor. This brought about the conversion of the Rus prince of Scandinavian origin, who had united Poland and White Russia to Ukraine. However, anxious to maintain his independence, Vladimir did not place himself under the patriarch of Constantinople, but rather decided to align himself with the small Bulgarian patriarchate created by Cyril and Methodius. And it was with their liturgical texts in Old Slavonic that he converted what would become "holy Russia."

VICTOR
VASNETZOV
(1848–1926)

*The Baptism of
Russia in 988*

Tretiakov Gallery,
Moscow

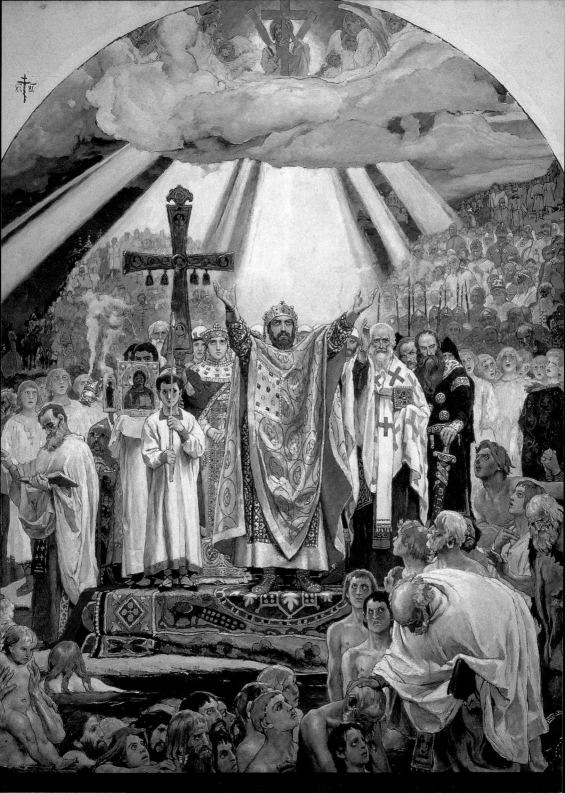

The Period of Pornocracy

This period, the most troubled in all the history of the Roman Church, began in 896 when Pope Stephen VI had his predecessor, Formosus, exhumed and his corpse brought to trial, dressed in pontifical vestments. The outcome of this "Cadaver Synod" was that the dead pope was declared guilty — the three fingers used for consecration were cut from his hands, and his remains were thrown into the Tiber.

Stephen VI himself was strangled soon afterwards, and the dark clouds of madness settled upon the papacy. In the beginning of the tenth century, the Roman prince Theophylactus had the lover of his daughter Marozia elected pope, as Sergius III. Later, Marozia had John X (the lover of her mother) assassinated, so as to have her son by Sergius III placed on the pontifical throne, as John XI.

A grandson of Marozia by another liaison was pope under the name of John XII. He was deposed by the German emperor Otto I, who seized Rome and charged him with polygamy, with castrating a cardinal, gouging the eyes of his godfather, and naming a ten-year-old as bishop. The emperor then appointed Leo VIII (who may not even have been baptized) as his successor, but the Romans reinstated John XII to the pontifical see. Soon afterward, the latter died in the bed of a woman, killed by her jealous husband. And so the century unfolded. It must be admitted that the survival of the papacy amid such an onslaught of scandals is nothing short of miraculous.

JEAN-PAUL
LAURENS
(1838–1921)

Pope Formosus and
Stephen VI

Musée du Petit-
Palais, Paris

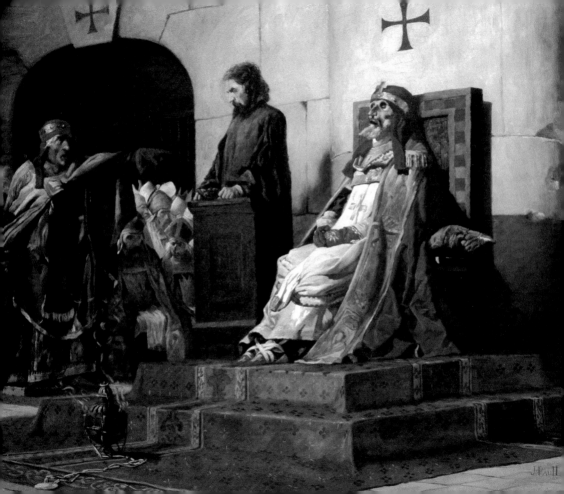

The Foundation of Cluny

In 910, the Duke of Aquitaine donated one of his tracts of land—located close to the Saône River, at the farthest ends of the territories under Roman and Germanic law—for the erection of a Benedictine abbey.

Its charter, approved by the bishops of the kingdom, included several novelties. It mandated that the monastery should strictly follow the rule of Saint Benedict, with its regular alternation of work and prayer. Most importantly, it ruled that Cluny, the said abbey, would not be under the authority of feudal lords, nor of the kings of France; neither would it be dependent on the bishops. It would respond directly to the pope alone. Finally, it was stipulated that the monks themselves would freely elect their own abbot.

This revolutionary model would quickly spread. Monks formed in Cluny took many a decaying monastery in hand, where they applied the new rule. The success of this measure was such that soon there were close to a thousand Cluniac communities throughout Western Christendom.

Besides its spiritual influence and expansion, the order of Cluny early played an important political role, supporting a centralized monarchy in opposition to feudalism and promoting the "truce of God" to curb the neverending seignorial wars.

Joos van Cleve
(ca. 1485–1540)

The Virgin and Child and Saint Bernard before the Abbey of Cluny

Musée du Louvre, Paris

The Weapon of Excommunication

Excommunication was a form of sanction used from the very beginnings of the church to chastise heretics and nonrepentant sinners. Those who were excommunicated were forbidden to partake of the sacraments and were removed from the community of the faithful, who were not to have any dealings with them. This punishment, both religious and social, greatly encouraged the sinner to repent.

In addition, excommunication played an important political role; beginning in the Middle Ages, it was decided that excommunication automatically deprived a ruler of his state and relieved his subjects of any obligation to obeisance. Such an anathema was pronounced — with varying degrees of success — against the emperors Henry IV and Frederic II, the kings Philip the Fair and Louis XII of France, John and Henry VIII of England, and Napoleon.

The first great political excommunication occurred in 998 against Robert the Pious, son of Hugh Capet, over his marriage. The church had no difficulties with his rejection of his first wife, Rozala, the daughter of an Italian king, because of her sterility, but it condemned the choice of his second wife, Bertha of Burgundy. It was deemed that this alliance was in effect a case of incest because they were cousins twice removed; the fact that they were godparents to the same child was also problematic.

But Bertha was also sterile and so Robert the Pious rejected her as well, which resolved the thorny predicament. So, without further difficulties, the king was able take a third spouse, Constance of Provence.

JEAN-PAUL
LAURENS
(1838–1921)

*The
Excommunication
of Robert the Pious*

Musée d'Orsay,
Paris

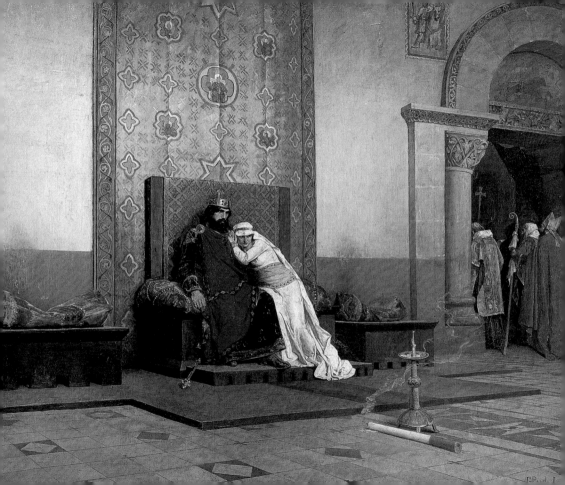

The Great Schism

Not all episodes in the history of the church have found their way into the annals of art. Art is selective about the themes it chooses; it could even be posited that a certain form of pictorial self-censure has been at play — one is not likely to celebrate on canvas what one would rather forget.

The Great Schism of 1054 is one of these seminal events that artists have passed by. Already in the ninth century, the patriarch Photius had condemned the formulation of the *filioque* (see p. 54) as heretical, and relations between the two poles of Christianity became ever more strained. The rupture was brought to a head by two strong personalities. Leo IX, in Rome, and the patriarch Michael Cerularius, in Constantinople, found a multitude of issues on which to oppose themselves: the length of a priest's beard, the composition of the sacred host, the authority of the pope, and, as always, the *filioque*.

Three months after the death of Leo IX, while the seat of Saint Peter was still vacant, a delegation that had been sent by the now deceased pope arrived in Constantinople and publicly proclaimed anathema against the Byzantine patriarch. He, in turn, replied by burning the bull of excommunication and severed relations with the papacy.

Thenceforth, the Catholic and Orthodox churches would take divergent paths, their differences becoming ever more pronounced over time. This rupture is evident even in the artistic expression of faith, with Western religious art having gradually strayed ever further from the iconic tradition.

Jovan Vasilievic
(eighteenth
century)

*Christ Bearing His
Crown*

Monastery of
Krusedol, Irig,
Serbia

80

The Humiliation of Canossa

Less than a century after the plight of Robert the Pious came another political excommunication of much greater import. In 1075, Pope Gregory VII, a monk of Cluny, published an edict reserving the right of nomination of bishops to the Holy See. Henry IV, the Germanic emperor, seeing himself deprived of his power of investiture, sought to depose the irksome pontiff, but Gregory responded by excommunicating the emperor. As the German lords took advantage of the situation to shake off imperial domination, Henry IV had no choice but to submit. He came to Tuscany, to the castle of Canossa where the pope was staying, and there had to wait for three days, bare feet in the snow, before Gregory VII would deign to receive and absolve him.

It was a false papal victory. As soon as the emperor regained authority over his vassals, he convened a council and had Gregory VII deposed.

The conflict was not resolved until 1122 with the Concordat of Worms, which determined that only the church could confer ecclesiastical authority, while bishops would continue to depend on secular powers for material matters.

This solution has endured. Still today, the very secular French Republic has implicit veto power over the nomination of bishops proposed by the pope.

EDUARD
SCHWOISER
(1826–1902)

*The Emperor Henry
IV in Canossa*

Maximilianeum
Foundation,
Munich

The First Crusade

The mounting dominance in the Muslim world of the Seldjuk Turks shook society well into the West. Almost all of Asia Minor was seized from Byzantine control, and pilgrimages to the Holy Land, which until then had remained accessible under the caliphs, now became impossible.

In 1095, Pope Urban II officially launched the Crusades at the Council of Clermont-Ferrand, kindling immediate and widespread enthusiasm for the enterprise. The first mobilization effort occurred under Peter the Hermit, a monk, and Walter the Penniless, who led thousands of inexperienced peasants in their march toward the east. Sowing pillages and pogroms in their wake, they reached the Bosporus strait, only to be soundly defeated by the Turks.

Meanwhile, the great lords of Europe organized four armies, commanded by Bohemond of Taranto; Raymond of Saint-Gilles, Count of Toulouse; Hugh of Vermandois; and the Duke of Lower Lorraine, Godfrey of Bouillon.

Once in Asia Minor, these grand knights, behaving like good feudal lords, preferred establishing principalities for themselves above proceeding on to the Holy Sepulcher: Bohemond of Taranto became Prince of Antioch, while Baldwin of Boulogne seized the town of Edessa.

FRENCH ILLUMINATION ("Passage Overseas by the French," 1490)

Bohemond's Army before the Turks, on the Vardar River

Bibliotèque Nationale, Paris

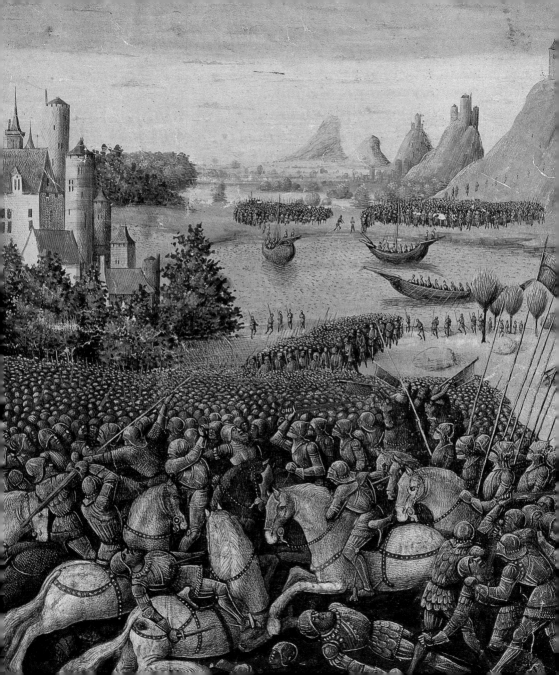

The Taking of Jerusalem

The arrival of the crusading armies in Asia Minor upset the balance of the region, and the first to profit from this state of affairs were the Muslims. The caliphate of Cairo, rival of the Turkish-dominated caliphate of Baghdad, took advantage of the circumstances to seize Palestine and Jerusalem on August 26, 1098, and expel the Turks.

They would not remain there for long. Capitalizing on the debilitating enmity dividing Muslim brethren, the crusaders, led by Raymond of Saint-Gilles and Godfrey of Bouillon, took the city in June 1099.

The extent of the massacre and pillaging that ensued was only matched by the fervor with which the crusaders wept for joy at each station of the *Via Dolorosa* (Way of the Cross). Assembled before the grand mosque, with blood "down to their ankles," the ruffian soldiers turned the city over to Godfrey; but he, refusing to don the royal crown where the Lord had once borne the crown of thorns, took the title of Defender of the Holy Sepulcher instead.

The repercussions of this victory were immense and lasting. In 1593, the Italian poet Torquato Tasso published his *Jerusalem Delivered,* a work that would inspire painters well into the nineteenth century.

KARL THEODOR
VON PILOTY
(1826–1886)

*The Crusaders
Enter Jerusalem*

Maximilianeum
Foundation,
Munich

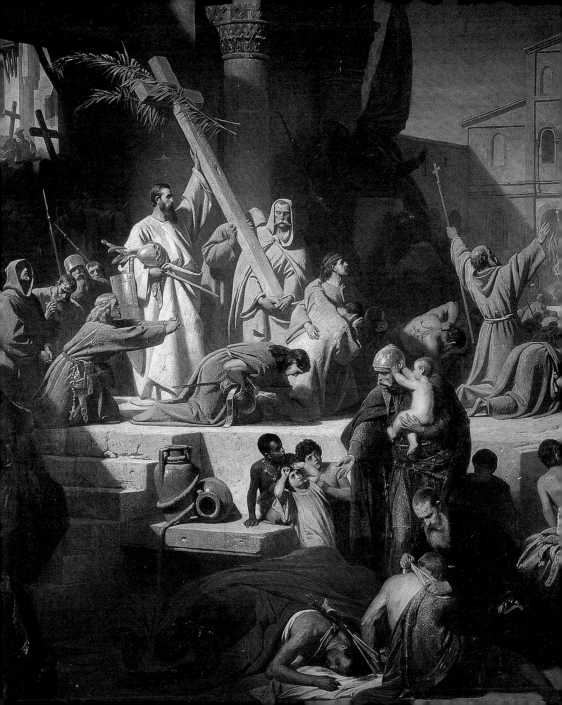

The Reform of Saint Bernard

The son of a wealthy family of Burgundy, Bernard entered the Abbey of Cîteaux in 1112, bringing along with him 30 companions (from Cîteaux comes the name of the Cistercian monks). Three years later, he was charged with founding a new abbey in Clairvaux, the first of 72 monasteries he would establish across France (where the monks were called Bernardines).

The reforms he implemented brought about strict observance of conventual rules and also an improvement in the material conditions of the monasteries. His reputation for piety and his eloquence soon reached beyond monastic circles and led him to act as counselor and arbiter in the great theological debates of the time, including in Rome.

His disputes with the philosopher and theologian Peter Abelard (lover of Eloise) — whom he had condemned in 1140 at the Council of Sens — are well known. Also, it was Saint Bernard who, in 1145, preached the Second Crusade.

At times he is mistaken for another Saint Bernard, of a previous century, who founded hospices in the Alps to provide refuge to travelers and who gave his name to two mountain peaks and a breed of dogs.

Giuseppe Passeri
(1654–1714)

*Saint Bernard
Entering the
Monastery of
Cîteaux*

Musée des Beaux-
Arts, Dijon

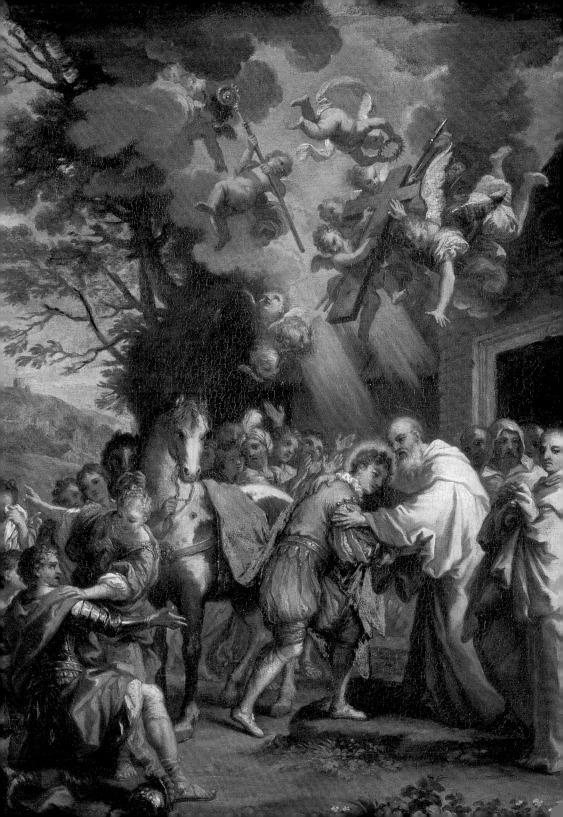

Popes and Antipopes

Because of longstanding imprecision in the procedures regulating the election of the sovereign pontiff, a considerable number of disputes arose over the course of time, which led to no fewer than 39 antipopes in the history of the church.

At times, determining the legitimate successor of Saint Peter was a difficult enterprise, with each pretender having solid arguments in his favor and sincere partisans supporting his cause. This was the case after the death of Pope Honorius II in 1130. The electing cardinals were divided, forming two separate colleges — the largest group elected Anacletus II, while the others bestowed the pontifical tiara on Innocent II.

As the greater numbers and temporal strength were in favor of Anacletus, his opponent fled from Rome to France — a good choice of destination. There, King Louis the Fat convened a council in Etampes to settle the conflict. Thanks to the influence of Saint Bernard of Clairvaux, Innocent was declared the legitimate pope in 1131 and from then enjoyed the support of the sovereigns of France, Germany, and England.

However, Anacletus remained firmly in Rome with the aid of the Normans of Sicily. Confusion reigned for another eight years until his death definitively legitimized the position of Innocent II.

Some paintings witness to this episode in church history, but without indicating the exact status of Anacletus.

PALMA IL GIOVANE
(*alias,* JACOPO
NEGRETTI)
(1544–1628)

Anacletus II
Founds the
Fraternity of the
Crociferi (Bearers
of the Cross)

Oratory of the
Crociferi (Bearers
of the Cross),
Venice

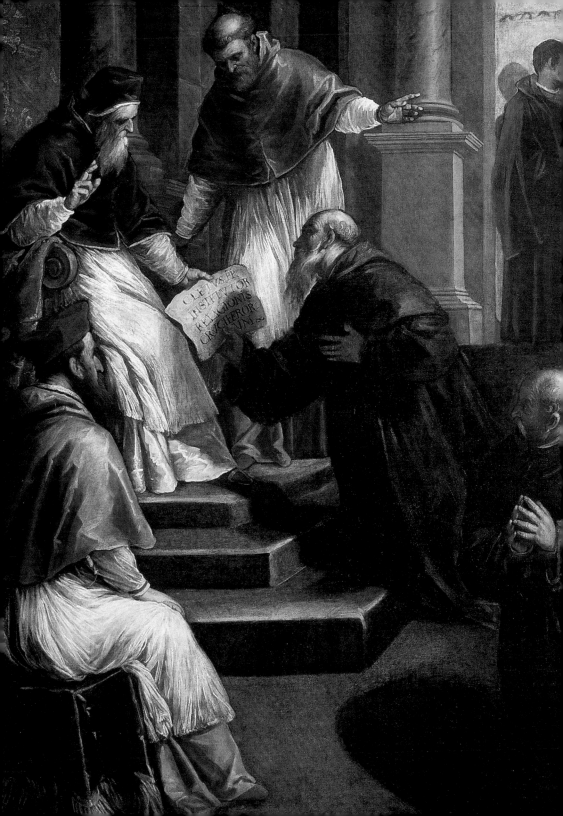

CLEMS.PP
INSTITVTOR
RELIGIONIS
CRICIFERORO
VM

Christ's Knights

The Crusades gave rise to a very particular type of religious institution, with a fascinating history — the military order, created with the establishment of the Order of the Temple (Knights Templar) in 1129. There followed the Knights Hospitaller, precursors of the Knights of Malta, and the Order of Saint-Lazarus, which included leper knights in its ranks.

Other military-religious groups would emulate this structure. The Livonian Brothers of the Sword appeared in Germany in 1147 to engage in a crusade against the pagans of northern Europe. Later, the reconquest of Spain from the Moors would occasion the formation of the military orders of Calatrava, Alcantara, and Santiago.

These orders were directly under the papacy, and so completely exempt from both civil and local ecclesiastical authorities. As long as they kept to their original role, that is, as long as they maintained the Holy Land, no one questioned their power and their wealth.

In subsequent centuries, the Knights of Malta generously patronized the arts in their island nation. The other orders, however, would inspire painters only in the nineteenth century, when Romanticism rediscovered the Middle Ages.

FRANÇOIS-MARIUS
GRANET
(1775–1849)

*Chapter Meeting
of the Order of the
Temple in 1147*

Château de
Versailles,
Versailles

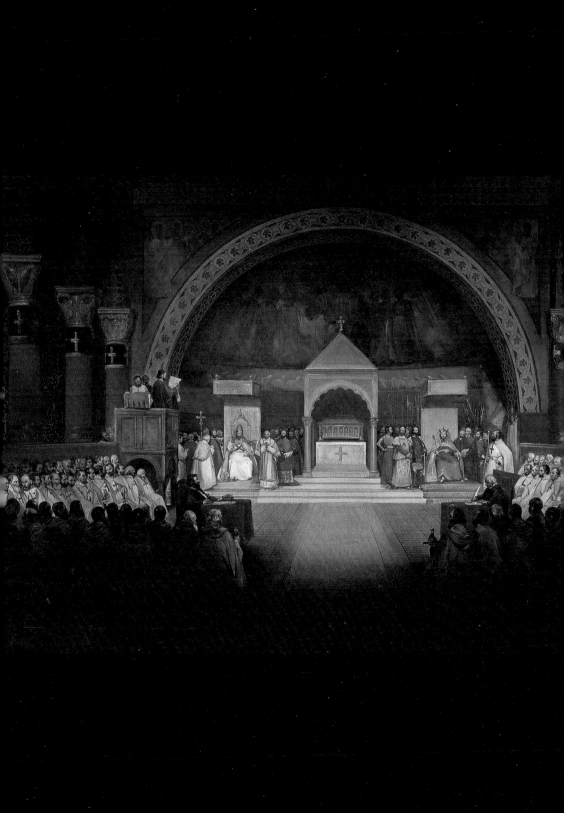

Murder in the Cathedral

In 1162, King Henry II of England believed he had made a clever move by appointing Thomas Becket, his chancellor and companion in social pleasures, to the archbishopric of Canterbury. Until then, this Norman from Rouen had proven himself to be a perfect courtier, and the monarch counted on him to secure his authority over the church in England.

But the newly promoted official took his episcopal dignity very seriously and opposed his king when the latter moved to tax the lands of the church and claim judicial authority over the clergy.

Rather than submit, Becket fled to France, taking refuge under the protection of Louis VII, an enemy of the king of England. The exile lasted six years, until a compromise was reached and Becket was able to regain his see. However, in substance nothing had truly been settled, and the disputes resumed until four courtiers, taking to heart the exasperation of their king, murdered the archbishop in his cathedral, at the foot of the altar, on December 29, 1170.

Great was the scandal, and immense the religious fervor it evoked. Thomas Becket's tomb became a place of pilgrimage, especially for the Saxon population, ever hostile to the Norman occupants. And the king did public penance, even having himself scourged before the monks of Canterbury.

The martyrdom of the archbishop left a long-lasting impression in the arts, inspiring both painters and authors. Chaucer's *Canterbury Tales* has as background a pilgrimage to Becket's tomb. The Nobel Prize–winner T. S. Eliot dedicated a play to him, as did the Frenchman Jean Anouilh.

ALFRED RETHEL
(1816–1859)

*The Murder of
Thomas Becket*

Gemäldegalerie
Alte Meister,
Dresden

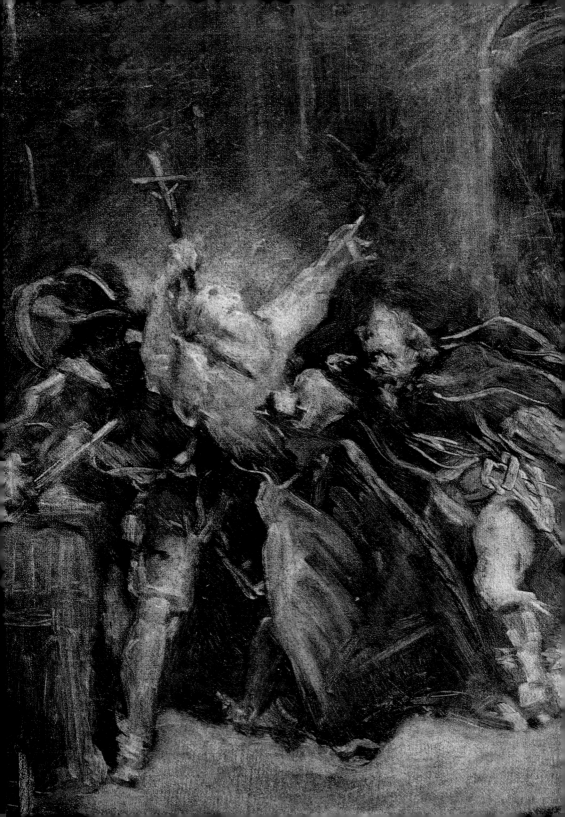

Venetian Power

One full century after Canossa, despite all the treatises, the conflicts between the Holy See and the German emperor reemerged. This time, it was Pope Alexander III in opposition to Frederick Barbarossa, who installed an antipope in Rome. But the plague decimated his army, and he was forced to retreat.

During the occupation, Pope Alexander had taken refuge in a monastery in Venice, and so the city of the Doges served as the venue and intermediary for the reconciliation between papacy and empire. Thus, on July 24, 1177, Barbarossa recognized Alexander as the legitimate pontiff, and the latter acknowledged the temporal power of the emperor as not being subordinate to spiritual authority. In a way, this agreement prefigured the separation of church and state.

Venice emerged all the stronger from the episode. In gratitude for their role in the affair, the pope conferred on Doge Ziani an unprecedented form of dominion over the Adriatic Sea, declaring, "May the sea be submissive to you as a wife to her husband."

Since then, Venice holds an annual celebration of its espousals to the Adriatic Sea in which a gold ring is solemnly thrown into the waters by the Lido. Along the centuries, Venetian artists have never ceased to recall this papal legitimization of the power of their city.

FRANCESCO
BASSANO, THE
YOUNGER (*alias,*
FRANCESCO DA
PONTE)
(1549–1592)

*Alexander III Sends
the Blessed Sword
to Doge Ziani*

Palazzo degli Dogi,
Venice

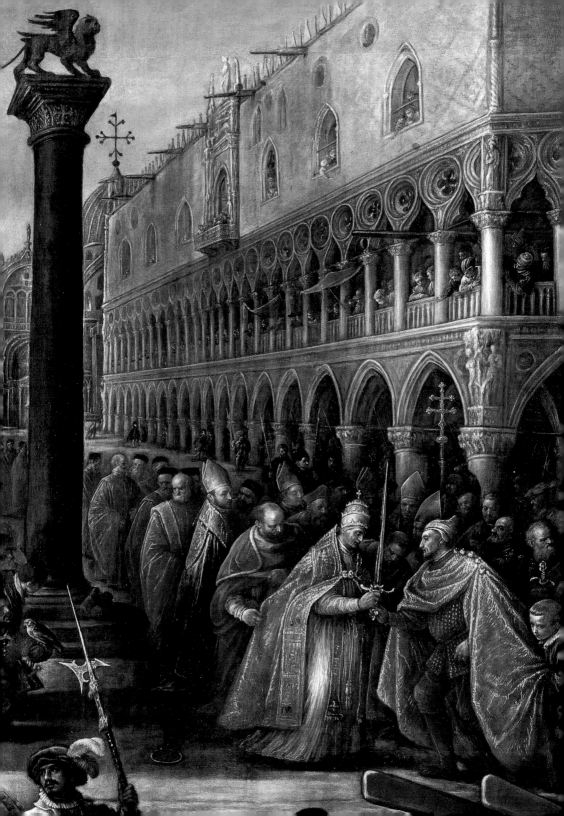

The Third Crusade

The capture of Jerusalem in 1099 had not fully guaranteed security for the crusaders in the Holy Land. The Second Crusade, preached in Vezelay by Saint Bernard in 1145, had come to a sudden end in two years' time without any notable events other than the pillaging of some Greek villages by the crusaders.

The fall of Jerusalem in 1187 was the occasion for the Third Crusade, in which three prestigious rulers took part: Frederick I Barbarossa of Germany; Richard I, the Lionheart, of England; and Philip II of France. To finance the enterprise, a new tax was levied in Christian lands called the "Saladin Tithe," after the Muslim leader who had seized Jerusalem.

In May 1190, Barbarossa won a resounding victory over the Turks in Iconium, Asia Minor, but he subsequently drowned while crossing the Saleph River. Philip returned to France one year later, to attend to the affairs of his realm. As for Richard the Lionheart, after two years of indecisive fighting, he concluded a truce with Saladin with mutual guarantees for Christian pilgrims to Jerusalem and Muslims on their way to Mecca.

The Third Crusade gave rise to a wide variety of legends and epics, the French, English, and Germans each naturally favoring their respective sovereigns. This nationalistic perspective is also reflected in artistic renderings of the crusade.

KARL FRIEDRICH
LESSING
(1808–1880)

*Barbarossa in the
Battle of Iconium*

Volmer Collection,
Wuppertal,
Germany

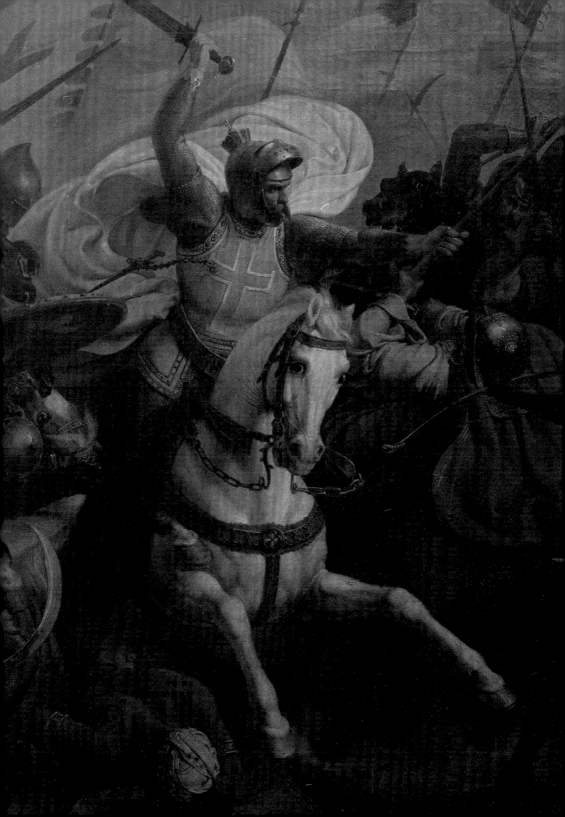

The Capture of Constantinople

After a century of crusading, enthusiasm had waned; volunteers were in shortage, as were funds. When Pope Innocent III preached a Fourth Crusade, only 10,000 knights enrolled. The crusaders hired Venetian ships to transport them to Egypt, where the confrontation was planned to take place. However, as they had not been able to amass the amount needed to pay for the fleet, a compromise was reached through which the Venetians participated in the expedition. As a result, a detour was made to Zara, a port in Croatia and therefore a Christian city, which was seized by the Venetians as compensation.*

"It is only the first step that is difficult," as the Marquise du Deffand would say. The knights then proceeded to Constantinople, which they seized and pillaged on April 13, 1204. This brought about the establishment of a Latin Empire in the East, entrusted to Baldwin of Flanders, which purportedly brought an end to the Schism. It lasted only 50 years, for in 1261, Michael Palæologus restored Orthodox sovereignty to the city. Nonetheless, the Latin presence remained through a French holding in Morea, that is, the Peloponnese, until the Ottoman occupation.

This derailing of the crusade was a great scandal at the time, but less than one would imagine today. Invading the schismatics was only slightly less legitimate than attacking the Muslims. Besides, the regularity with which Venetian artists have celebrated the event through the centuries stands witness to a perfectly good conscience.

TINTORETTO
(1518–94)

The Sack of Constantinople

Palazzo degli Dogi, Venice

* Both the taking of Zara and the pillage of Constantinople were a scheme of the Venetians, planned and executed by their Doge, Enrico Dandolo. For this they were excommunicated by Pope Innocent III. — *Trans.*

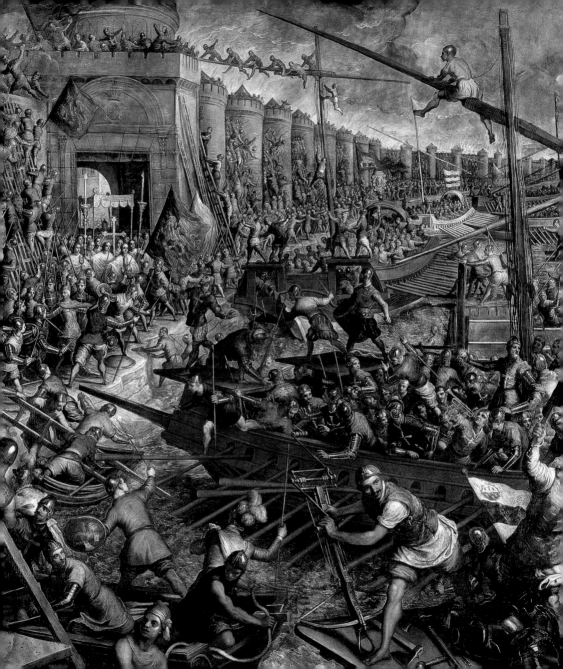

The Teutons of Prussia

Originally, the confraternity of the Knights of Saint Mary's House of the Teutons in Jerusalem was simply a military order like others. It was created in 1190 in Saint John of Acre to help Germanic pilgrims to the Holy Land and to care for wounded crusaders.

Hermann von Salza, its grand master from 1211, profoundly changed the character of the order. After warring in the Holy Land for many years, he became an indispensable diplomat, helping to settle differences between the Germanic Empire and the Holy See. In 1230, he launched a crusade against the pagans of Prussia and the Baltic countries.

It took 50 years for the Teutonic Knights (who, in the meantime, had incorporated the Livonian Brothers of the Sword) to complete this evangelization of Prussia by the use of arms. The Christianization of the Baltic countries came about only much later, after two centuries.

On the other hand, the Teutonic Knights failed before the young Orthodox Russia. In April 1242, Prince Alexander Nevski dealt them a bloody defeat at the borders of Estonia.

The Teutonic order was mostly absorbed by the reform of Luther and disappeared in Prussia, continuing as such only in the Catholic areas of Germany. It was abolished by a decree of Napoleon issued in 1809. However, the order still exists in Germany as a charitable organization.

CARL WILHELM
KOLBE
(1781–1853)

Innocent III
Bestows the Ring
of Command on
Hermann von Salza

National Palace,
Berlin

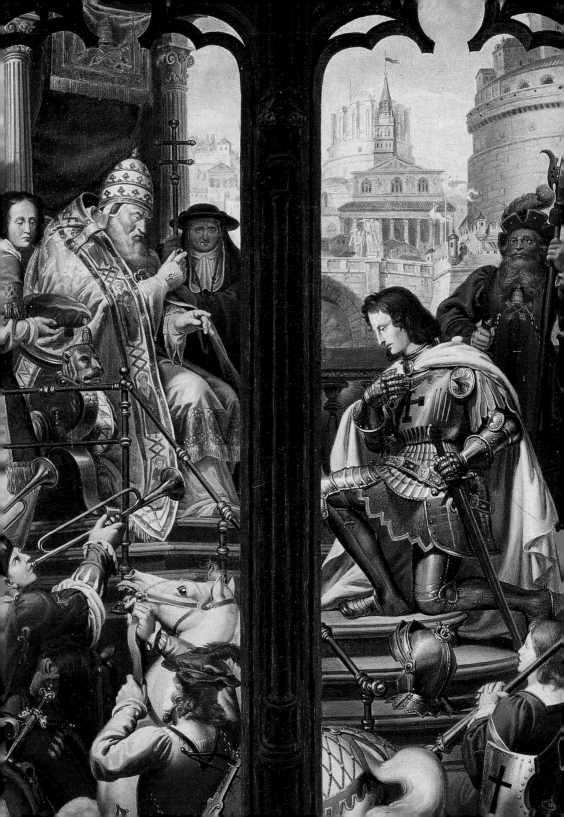

First Stakes

To the extent that the number of theologians increased with the development of Christianity, so grew the risk of heresies emerging. This was notably the case beginning in the twelfth century. In Italy, Gioacchino da Fiore escaped being condemned, while in France condemnation fell successively upon Jean de Bruys; Abelard; Henri de Cluny; Amaury de Chartres and his followers, the Amalricians; and Pierre de Vaux (Petrus Waldus) and his Waldenses.

The church was particularly concerned about the development of a sect that had its origins in the Middle East, influenced by the ancient dualism of the Manicheans. Its adepts were variously called Cathars, Albigensians in the south of France, Bonshommes, or Bugres, because they purportedly came from Bulgaria. In Bosnia they were known as Bogomils, and their great numbers massively and easily converted to Islam upon the invasion of the Ottoman Turks.

Various successive councils condemned the heresy, convening in 1163, 1165, 1179, 1184, 1215, and 1229. In 1209, a crusade was launched against the Albigensians, beginning with the sack of Béziers, a town that had given shelter to 222 Bonshommes. More than 20,000 of the population were killed, which gave rise to the legendary comment attributed to Arnald-Amalric, archbishop of Narbonne: "Kill them all; God will recognize his own."

Dispossessed of their fiefdoms by the crusaders of the north, the nobles of the south of France resisted the invaders with equal ferociousness. When peace returned in 1242, the area around Toulouse had become definitively attached to the kingdom of France, while Avignon and the surrounding Comtat fell to the papacy.

JEAN FOUQUET
(ca. 1425–ca. 1480)

(illumination in the *Chronicles of Saint-Denis*)

Burning of the Amalrician Heretics before King Philip Augustus

Bibliotèque Nationale de Paris

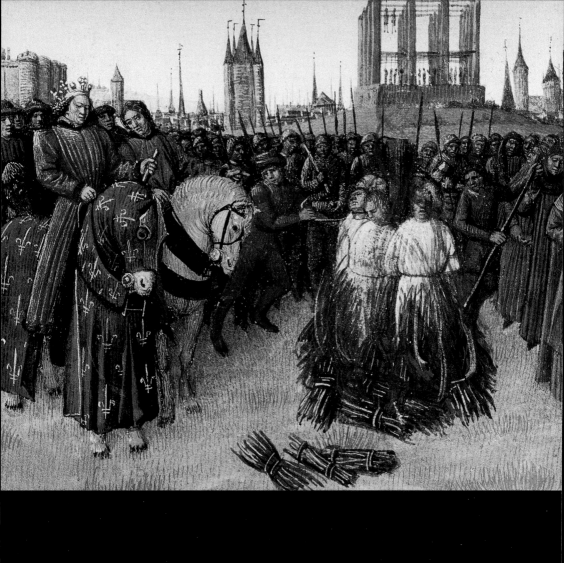

Dawn of the Inquisition

The Cathar heresy did not disappear with the peace of 1242. Some cells of adepts remained but were mercilessly crushed, as in Montsé-gur where 200 Cathars, men and women, were burned alive in 1244.

To carry out the religious dimension of the Albigensian crusade, Gregory IX instituted, in 1233, a special tribunal entrusted to a newly established religious order — the Dominicans, or Friars Preachers. Founded by Saint Dominic, a Castilian nobleman turned friar, the order's aim was to preach to and convert the heretics.

The methods of the Inquisition were both fierce and meticulous: accusation, torture, investigation and gathering of testimonies, trial independent of the secular arm, and public execution (entrusted to the temporal authority) according to strict procedure — all of which signaled great progress in juridical history. It is commonly acknowledged that the Inquisition, according to Saint Dominic, forms the basis of the modern judicial system!

But this was not the essence of the work of the Dominicans. Their dominant activity was preaching, and it was preaching that converted the heretics.

With the emergence of such "mendicant" orders (orders that lived on alms), including the Franciscans, the face of monasticism was completely changed. These friars, like the secular clergy, had a pastoral vocation, which meant they were not solely dedicated to the contemplative life. This was the most impressive religious innovation of the Middle Ages. One of the first Dominicans, Jacobus de Voragine, wrote *The Golden Legend* at the end of the thirteenth century, a collection of lives of the saints intended to provide material for sermons. The work profoundly influenced religious art, providing artists with countless themes to illustrate.

PEDRO
BERRUGUETE
(ca. 1450–1504)

*Saint Dominic
Burning the
Writings of
Albigensians*

Museo del Prado,
Madrid

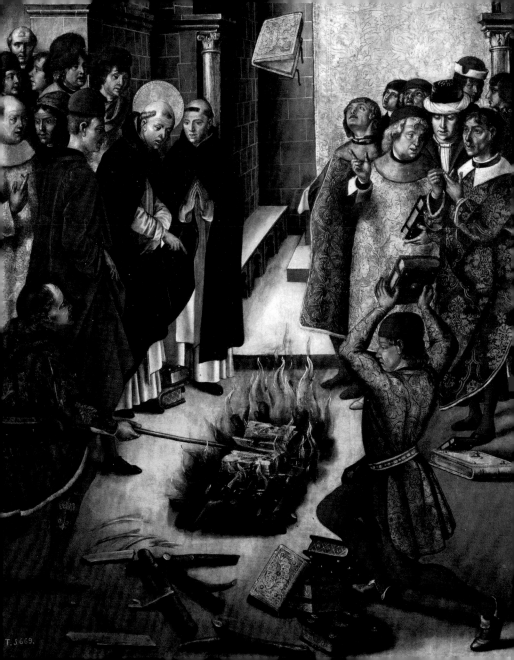

T.J.669.

The Arrival of the Franciscans

On Christmas 1223, the faithful of the Italian town of Greccio, upon arriving at their church, discovered an unprecedented scene: the prop of a cave, an ass, and an ox before a manger. And thus was born the first nativity scene, by the initiative of Saint Francis of Assisi.

Shortly before the Spaniard Dominic founded his Order of Preachers, a young Italian bourgeois had created his own, under the name of "Friars Minor." He insisted on literal fidelity to the Gospel in reaction to the intellectualism of theologians, advocating, above all, the simplicity of its message and the life of poverty. Like the founder of the Dominicans, Saint Francis introduced a new form of religious life with his noncloistered friars who, like secular priests, could administer the sacraments to the faithful.

His endeavor enjoyed immediate success, while also giving rise to controversy.

Through an erroneous intellectual interpretation of his approach, certain groups emerged favoring individualist mysticism, such as the Brothers and Sisters of the Free Spirit, the Fraticelli, the followers of Gioacchino da Fiore, and the Poor Hermits. Today, the Franciscans (or some of its members) are reproached for their atheistic pantheism and their revolutionary egalitarianism. In *The Name of the Rose*, Umberto Eco portrays the disputes that pitted the Franciscans against the Benedictines, as well as the Dominicans.

The numerous paintings that celebrate Saint Francis and his miracles, therefore, are not always exempt from an underlying apologetical tone.

Gᴇᴏʀɢᴇ ᴅᴇ Lᴀ
Tᴏᴜʀ
(1593–1652)

*The Ecstasy of Saint
Francis*

Musée de Tessé, Le
Mans

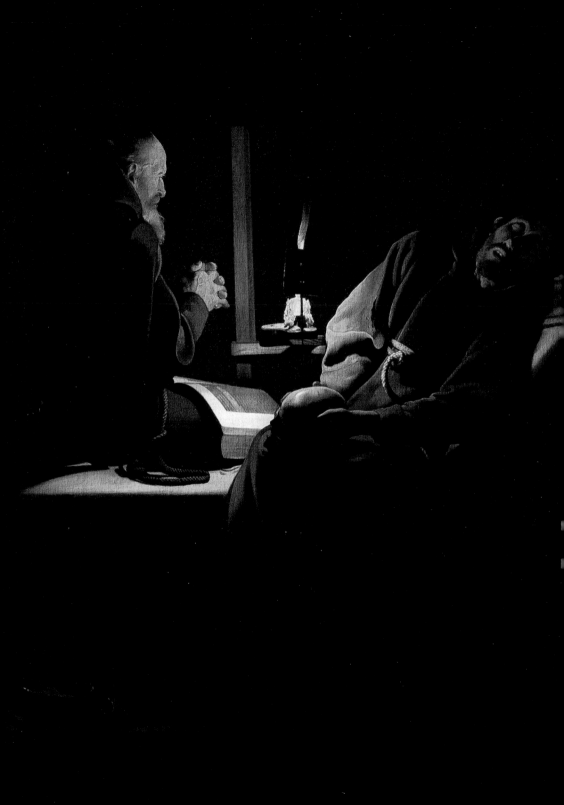

Guelphs and Ghibelins

The struggle between partisans of the papacy and those of the Germanic emperor was a common affair for Italians in the Middle Ages. However, this ongoing conflict took an unexpected turn in Florence, starting in the early thirteenth century, with the rivalry between two local patrician families. The Buondelmonti supported the Hohenstaufen emperor, lord of Waiblingen, whence the Italianized name "ghibellini"; the Arrighi family aligned itself with the Bavarian Welfen, papal supporters, whence the name "guelfi."

These feudal rivalries were rooted in ancient quarrels between the empire and the papacy, so that the Holy See saw itself swept into a whirlwind of civil wars from which it emerged all the better. To complicate things further, the partisans of the pope further divided themselves into Black Guelphs and White Guelphs.

The *Divine Comedy* of Dante comments on this civil war. The poet, at first a Guelph — and a white Guelph at that — become a Ghibelin in the course of writing his politico-religious epic poem.

The Ghibelins supported Frederic II of Hohenstaufen (known as Barbarossa), emperor of Germany and Sicily, whom Pope Honorius II excommunicated in 1227 for failing to honor his pledge to participate in a crusade. Despite this, he later embarked on the Sixth Crusade, but in his own way, signing a diplomatic agreement with the sultan of Egypt, which secured the religious neutrality of Jerusalem.

The church had no qualms about excommunicating Barbarossa a second time, in 1245, styling him an antichrist because of his religious eclecticism — he spoke Arabic and had a harem.

Giuseppe
Sabatelli
(1813–1843)

*Farinata degli
Uberti in the Battle
of Serchio*

Galleria Pitti,
Florence

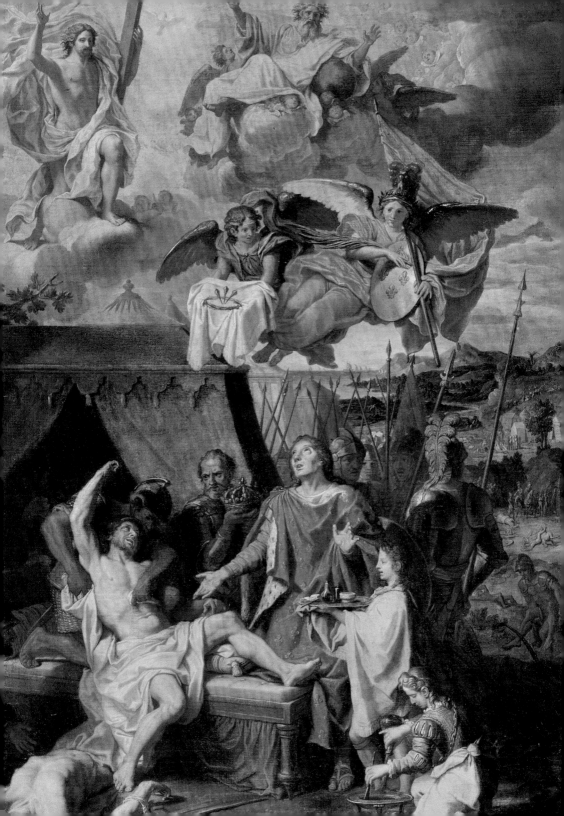

The Triumph of Scholasticism

The life of Thomas Aquinas gives the lie to the myth that the intellectual corpus of classical antiquity was ignored by the Middle Ages and only rediscovered in the Renaissance. Born close to Naples in 1225, Thomas was educated by the local Dominicans, who initiated him not only in theology, but also in the sciences and philosophy of the ancient Greeks, as well as the works of Islamic philosophers Avicenna and Averroes, both very much influenced by Aristotle.

Eventually entering the Dominican order, despite his family's opposition, the young Thomas studied at the universities of Paris and Cologne before becoming a professor of scholastics.

His immense scholarly output is entirely directed toward the reconciliation of faith and reason, of Holy Scriptures to the philosophy of Aristotle. The church, which had been more inclined toward Platonism until that point, would now be able to integrate and accompany the development of the secular sciences. This did not come without controversy. Thomas was accused several times, notably at the instigation of the Franciscans who rejected this "divinization" of reason, to which he retorted, "If we resolve questions of faith solely by way of Authority, we certainly will have the truth, but in an empty head!"*

Thomas Aquinas died in 1274, was canonized in 1323, and declared a doctor of the church in 1567.

FLEMISH
ILLUMINATION
FROM THE
BREVIARY OF
QUEEN ISABEL OF
CASTILE, 1497

* "So it is necessary to rest one's case on reasons which seek out the roots of the truth and which enable people to see how what one proposes is true. Unless one does this, if the master's response is based purely on authorities, the listener will know that things are so, but he will have achieved neither knowledge nor understanding and will go away with an empty head." — *Trans.*

Saint Thomas Aquinas

British Library, London

The Last Crusades

While the various crusading expeditions that followed the fall of Jerusalem in 1187 were never able to regain the city, they maintained a Christian presence in the Middle East. The crusaders would not leave the Holy Land completely until Saint John of Acre was taken by the Muslims in 1291.

Nevertheless, the Knights Templars and Hospitallers continued exerting a strong influence in the region, stationed at two islands turned into fortifications: Cyprus and Rhodes. These strongholds would only fall much later, in the sixteenth century, unable to resist the Ottoman Empire partly because of the indifference then prevalent in Catholic Christianity.

This indifference also explains an omission in Western history whereby only eight crusades are accounted for, to the neglect of four expeditions conducted by the Christians of Central Europe in an attempt to contain the rising Ottoman tide. Nonetheless, in 1396, the knights of the West joined forces with the Orthodox in Nicopolis, but in vain. On this occasion, the Turks gained their first great victory over the Christian coalition. Seven hundred French knights died to the cry of "Vive Saint Denis!"

Another coalition was formed in 1444, when the pope, the Byzantines, Burgundians, Venetians, Poles, and Hungarians united under the banner of Vladislaus of Poland seeking to lift the yoke that weighed upon Constantinople. All was in vain, yet again.

Two other attempts, in 1389 and in 1448, have been frequently referred to in more recent years. These were the defeats suffered in Kosovopolje, Serbian for "the field of blackbirds."

KARL FRIEDRICH
LESSING
(1808–1880)

The Return of the Crusader

Rheinisches
Landesmuseum,
Bonn

Franciscan Innovations

One century after the official recognition of the Order of Friars Minor in 1223, the Franciscans counted more than 40,000 members. These included not only the friars, but also religious sisters, attracted by the rule of Saint Clare who, like Francis, was born in Assisi. Following his example, she founded a community of women dedicated to the same vow of absolute poverty.

Francis of Assisi also created a "third order" adapted to the laity. While observing the rules of the friars' order, third order members could belong to the Franciscan community without leaving the world. Josemaría Escrivá would apply the same principle in the twentieth century with his movement Opus Dei, eliciting the same suspicions Francis's third order provoked.

At the margins of this movement, the béguinages emerged, growing ever more numerous, particularly in the Low Countries. These were communities of women who lived together, without following any precise rule, to serve the poor and sick or simply to live their faith. The beguines were often widows who entered into semiretirement in the heart of the cities. The operative lack of structure and control gave rise to deviations, and a number of beguines were accused of heresy, such as Marguerite Porete, burned at the stake in Paris in 1310.

Saint Francis implemented another innovation: at a time when the spirit of the Crusades was still prevalent, he conceived of a peaceful missionary effort into the Far East, with all the risks this might entail. In 1220, five of the early friars suffered martyrdom in Morocco.

GIUSEPPE
GAMBARINI
(1680–1725)

*Mendicant Friar
to Whom a Young
Girl Gives Eggs*

Musée du Louvre,
Paris

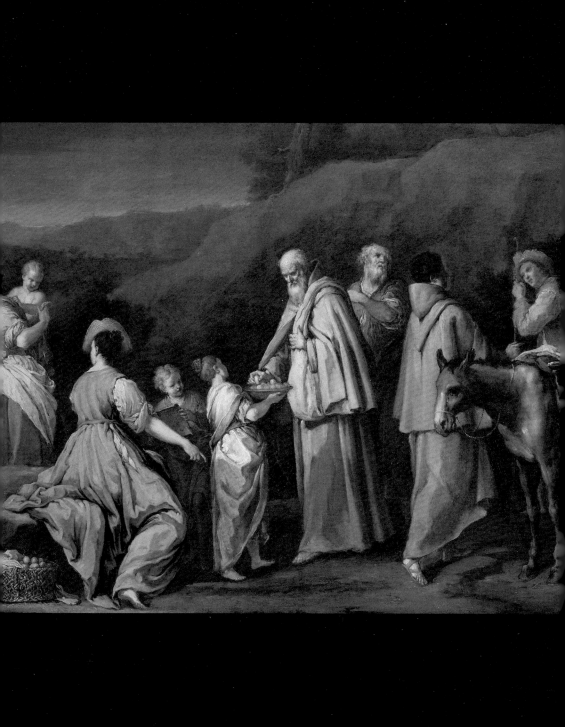

Pseudo Crusades

There were cases of spontaneous mobilization of the populace in the Middle Ages that have been referred to as crusades. Sparked by popular fervor for the retaking of the Holy Land, they were, more properly speaking, anarchical phenomena that were doomed to fail from the outset.

Already in the First Crusade, the impatience of the populace, which prompted them to depart without waiting for the leadership of the knights, resulted in a massacre. In 1212, in another popular movement — dubbed the Children's Crusade because of the youthfulness of many of the participants — thousands of French and German peasants launched upon the roads. The mass of people dispersed along the way, but hundreds of so-called crusaders still reached the ports of Provence, where they were taken aboard ship by unscrupulous merchants . . . to be sold as slaves on the opposite side of the Mediterranean.

In 1250, news of the captivity of Saint Louis triggered another mobilization of the people. This was the Shepherds' Crusade, its participants responding to the appeals of a mysterious Master of Hungary. Queen Blanche of Castile, who was regent during the absence of her son, had to suppress this uncontrollable movement, which mostly went about pillaging wherever it passed.

In 1320, there was again mention of "shepherd crusaders," but this was less a religious movement than a rampaging mob that left numerous pogroms in its wake.

FRENCH ILLUMINATION, (*Chronicles of France,* ca. 1375–1380)

The Shepherds Burn the Tower of Verdun-sur-Garonne where Five Hundred Jews Had Found Refuge

British Library, London

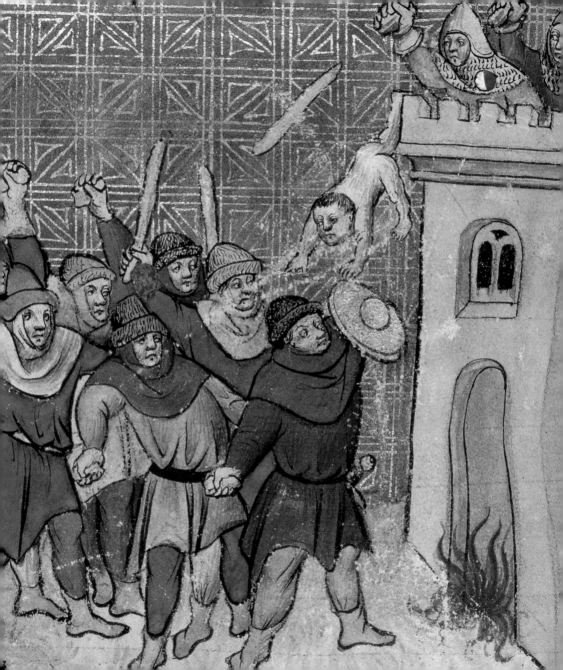

The Attack at Anagni

In the beginning of the thirteenth century, the neverending conflicts between the French monarchy and the papacy over the matter of competence took a dramatic turn. In 1301, Philip the Fair imprisoned the bishop of Pamiers, who had been plotting to have the county of Toulouse secede from France. Philip decided to have the traitor prosecuted by a civil court instead of an ecclesiastical court.

In response, Pope Boniface VIII convened a council and threatened the king with excommunication, a bewildering prospect that would expel from the church the grandson of Saint Louis, whom the same pope had just canonized!

Supported by a good portion of the high-ranking clergy of France, Philip the Fair decided to convene a council himself...to depose the pope. He sent his minister, Guillaume de Nogaret, to Italy to seize the person of the pontiff, and as Nogaret had only a small escort with him, he hired the henchmen of the Colonna family upon arriving in Rome. The Colonnas were in longstanding rivalry with the family of the pope.

Arriving at the palace located in the pope's native town of Anagni, the band forced his door open. There ensued a tumultuous scene; one of the attackers even tried to slap the pontiff's face. However, the local peasantry rose in defense of the pope, and the attempted abduction was thwarted. But for Boniface VIII, it had been too much. He died of humiliation and pain a few days later.

FRENCH ILLUMINATION (*Great Chronicles of France*, end of the fourteenth century)

Death of Boniface VIII after the Attempt at Anagni

British Library, London

De la mort au pape boniface

Nest an enfement quant le pa

Sojourn in Avignon

On one side, there was Rome and Italy, ever torn by conflicting factions. On the other, the kingdom of France, growing in power, where the king's authority, while onerous, was at least a guarantee against the intrigues of the Roman families. Faced with such a scenario, Bertrand de Got, elected to the papacy in 1305, made his decision, aided especially by the fact that he was a Frenchman (born in Aquitaine, he was the archbishop of Bordeaux).

He chose to be enthroned in Lyons, under the name of Clement V, and forfeited reaching Rome, staying instead in the city of Avignon, which had been part of the papal domains since the Albigensian crusade. The result was an unheard of state of affairs: Rome was no longer in Rome. For 77 years, the town that was now called the City of the Popes and the surrounding Comtat region would be the center of Western Christendom. There were seven popes in Avignon, followed by two antipopes.

Gregory XI's return to Rome in 1377 reignited the Roman factions. When the time came to elect his successor, they constrained the cardinals, by way of threats, to choose an Italian. However, a number of these cardinals declared the election invalid and elected another pope, who forthwith was installed in Avignon.

A council was convened in Pisa, in 1409, but this did not resolve the Great Western Schism, as the participants deemed it more expedient to depose the two competing pontiffs in order to elect a third one. Not until the Council of Constance and the election of Martin V in 1417 was unity restored.

FRENCH
ILLUMINATION
(*Great Chronicles
of France,* end of
the fourteenth
century)

*Crowning of
Clement V in Lyon*

British Library,
London

terne ylabel la fille plx le bel roy de france.

The End of the Templars

The Order of Knights Templar had imperceptibly amassed enormous wealth over time. Protected by the pope, it was exempt from taxes and received copious donations. The number of their commanderies, stationed along all the routes leading to the Holy Land, reached the thousands, with 2,000 in France alone.

In addition, the Templars administered the properties of crusaders who left for Palestine, which soon placed at their disposal a financial network unique in the entire continent; even the rulers of Europe often had recourse to them.

However, all their privileges and power lost any legitimacy once the Templars left the Holy Land in 1291. Moreover, it was rumored that the Battle of Hattin, which led to the fall of Jerusalem, had been lost because of their incompetence, perhaps even because of their treason.

On October 12, 1307, the sergeants of the king of France proceeded to round up and imprison all the Templars in the kingdom. It was a master stroke: very few escaped, particularly as, soon afterwards, the pope ordered the arrest of all Templars throughout the Christian world.

Sodomy, sorcery, idolatry, adoration of a mysterious Baphomet — these accusations, among others, were confirmed under torture. In 1312, the pope dissolved the order. Jacques the Molay, its grand master, suffered another two years of torments before being burned alive in Paris, with three companions.

FRANÇOIS
RICHARD FLEURY
(1777–1852)

*The Grand Master
Templar, Jacques
de Molay*

Musée du Château,
Rueil-Malmaison

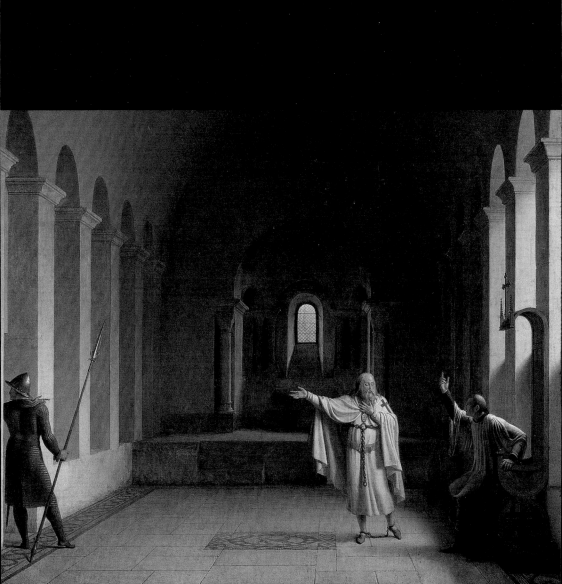

Turlupins and Beghards

Item aux frères mendiants,
Aux dévotes et aux béguines,
Tant de Paris que d'Orléans,
Tant turlupins que turlupines.

[The same to the friars mendicant,
To the pious and the beguines,
Be they in Paris or in Orleans,
Be they male or female turlupins.]

In this verse of his *Grand Testament*, François Villon—a graduate of the University of Sorbonne, and thus of Dominican leanings—plays with a very polemical combination, juxtaposing the order of the Franciscans to a heresy that could lead to the stake.

A combination of often verified deviations by adepts of Saint Francis, with the name that the turlupins adopted for themselves, Fraternity of the Poor, gave occasion to this confusion. But the Franciscans never preached nudism or swinging, this heresy's two great innovations, leading to its condemnation in 1312 and again in 1378.

It is not entirely out of the question that the turlupins, also called beghards (from the English word beggar), might have emerged at the fringes of the third order of Saint Francis. And while the church was careful to separate the wheat from the chaff, public opinion, well represented by Villon's verse, was not encumbered by such subtleties and heartily approved the burnings carried out under Charles V to eradicate the heresy.

FRENCH
ILLUMINATION
(anonymous
chronicle
translated by
Bernard Gui,
fifteenth century)

*The Turlupins
Burned Alive at the
Ponceaux Fair,
by the Porte
Saint-Honoré in
Paris*

Municipal Library,
Besançon

The First Protestant

He wasn't just anyone. A renowned theologian, rector of the University of Prague in 1409, and confessor to the queen of Bohemia, Sophia of Bavaria, John Huss at first appeared to be a reformer seeking to restore morality to the clergy. However, the influence of an English heretic, John Wycliffe, gradually led him to preach in a way that foreshadowed Protestantism. He rejected the validity of indulgences, the cult of the Virgin Mary, and the authority of the pope. And since he preached and wrote in the local language, Czech, his influence in the region grew steadily.

Excommunicated as a result, he went to the Council of Constance in 1414 to present an appeal, bearing a safe-conduct from Emperor Sigismund. However, the imperial guarantee was of no help to him. When he refused to recant after having been declared a heretic, John Huss was burnt to death at Constance the following year.

The Council of Constance was convened by John XXIII (rumored by some malicious tongues to be an old pirate captain) who was deposed by the same council and declared an antipope. He then declared his submission to his successor, Martin V, thus bringing an end to the Great Western Schism. In 1958, Angelo Roncalli took the name John XXIII, thereby signifying that the first John XXIII had never existed as pope.

ANONYMOUS
(sixteenth century)

John Huss

Hussites and Moravian Brothers

The death of John Huss was not the end of his dissension. In Bohemia, his partisans took to arms under the leadership of Jan Žižka and Nicholas of Hussinetz, reckoning war to be an extension of theology by another means.

They were successful at first, defeating the imperial army several times. In fact, the Hussites waged a type of Czech nationalist (i.e., Slavic) war against the Germanic Empire, and therefore enjoyed the support of other non-Germanic peoples, notably the Poles and Lithuanians. Despite the death of Žižka in 1424, the conflict endured for another ten years.

The Hussites never disappeared. Known as the Moravian Brethren, they continued on in Bohemia, Prussia, and Poland. Having attached themselves to the Protestant movement without fully integrating themselves to it, they slowly expanded outside of their original enclaves. Today, they number about 800,000, present most notably in the United States, where they founded the city of Bethlehem, Pennsylvania.

GERMAN SCHOOL
(fifteenth century)

John Žižka of Troconov

Ambras Castle, Innsbruck

ARICIÆ CLERICORVM SEVERVS VLTOR

Joan at the Stake

The story of Joan of Arc is not only a national epic of France, but also an extraordinary religious adventure. It all began with supernatural visions. The archangel Saint Michael, Saint Catherine of Alexandria, and Saint Margaret of Antioch appeared to Joan, a young shepherdess of 18, instructing her to "expel the English from all of France."

The first miracle was the attitude displayed by Robert of Baudricourt, captain of Vaucouleurs, who provided Joan with an escort to take her to Charles VII at Chinon. The second miracle was that she readily recognized the king among his courtiers, and, by a secret sign that has never been revealed, convinced him of her mission. So strange was the adventure that Joan was submitted to a double examination — matrons were engaged to verify her virginity, and theologians, her orthodoxy.

In the course of a few days in May 1429, she freed Orleans from a seven-month siege sustained by the English, and then, by seizing Troyes, Auxerre, and Châlons, opened the way to Rheims for the king. On July 17, displaying her standard stamped with an image of Christ, she stood at the side of Charles VII as he received the ancient rite of consecration of French kings in the city of Saint Remigius.

After this triumph, there followed a long series of setbacks, leading to the stake in Rouen, on May 30, 1431.

Her trajectory after death was likewise strange. In 1456, a new trial nullified the original verdict of condemnation. Joan became a popular heroine, but not a saint. It was the very secular Republic of France that, in 1912, established a national holiday in honor of "Saint Joan of Arc," while the church had not yet canonized her. This did not happen until 1920, after some reticence on the part of Benedict XV.

PAUL DELAROCHE
(1797–1856)

*Cardinal
Henri Beaufort
Interrogating Joan
of Arc*

Musée des Beaux-
Arts, Rouen

The Triumph of the Papacy

By deposing two popes in one single stroke in order to appoint a new pontiff (without counting its obtaining the abdication of the third), the Council of Constance would seem to have confirmed the supremacy of an assembly of bishops over the pope. However, this conflict of authority reemerged during the neverending Council of Basel, held from 1431 to 1443.

Exasperated with conciliar intrigues and lengthy debates, the pope transferred the council to Ferrara, a town in closer reach. At this, the majority of the council fathers deposed him and elected the gentle Amadeus, Duke of Savoy, under the name of Felix V.

A grand nobleman who had become a saintly man, Felix, despite himself, donned the vestments of the antipope, which he bore for nine years while his rival, Eugene IV, continued occupying the See of Rome. Once again, there were two papal lines.

Nicholas V succeeded Eugene IV. The elderly Felix, sincerely afflicted by the situation, brought it to an end in 1449 by solemnly abdicating and acknowledging his rival as the true pope . . . who forthwith named him a cardinal!

The fathers of the council now understood: the supreme authority of the Catholic Church lay in Rome.

There was a second reversal at the Council of Basel (become Council of Ferrara and then of Florence). The reunification of the churches of the East and West was formally proclaimed at the council, with the agreement of the emperor of Byzantium. However, the Orthodox world, though under Turkish pressure, could not subscribe to an alliance imposed by their ruler and arrived at for political reasons.

BERNARDINO
PINTURICCHIO
(1454–1513)

*Eneas Piccolomini
(future Pius II)
arrives at the
Council of Basel*

Piccolomini
Library, Siena

The Fall of Constantinople

We will never know the gender of the angels with any certainty. A long debate carried on by Orthodox theologians, in hopes of at last obtaining a definitive response to the question, was interrupted by the fall of the city where they were holding their discussions.

The capture of Constantinople on May 29, 1453, was in reality the fall of a ghost town. The Turks already held dominion over Asia Minor and the Balkans, having established their capital in Adrianopolis, which they renamed Edirne. From there, Mehmed II launched his assault against the isolated and emptied city that could only muster 5,000 arm-bearing men.

In contrast, the Ottoman Turks mobilized a half million soldiers and the most powerful cannons of the day. Nonetheless, the Byzantines put up fierce resistance under the command of Constantine Dragases, the last Basileus, who was killed, sword in hand, at the breach of the Topkapi door.

Paradoxically, this defeat would be a comfort to Roman Christendom, which was left as the single free Christian center until such day as Moscow would propose to revive the Byzantine heritage. The catastrophe had staggering repercussions that still echo today; Prince Bibescu, drawing on words of the poet Lord Byron who died in 1824 for the liberation of Orthodox Greece, reflected, "The fall of Constantinople is a personal tragedy that happened to us last week."

PANAGIOTIS
ZOGRAFOS
(painted in 1836)

*The Capture of
Constantinople*

National Museum
of History, Athens

European Resistance

After the fall of Constantinople, Ottoman pressure on Western Christendom continued without respite for three centuries. The island of Rhodes fell in 1522. In 1529, after having conquered Hungary, Suleiman the Magnificent laid siege to Vienna, home of the Hapsburgs, but had to retreat before the city's heroic resistance.

Vienna would be saved from another siege, in 1683, thanks to a veritable crusade fought under the command of John III of Poland and Duke Charles of Lorraine. To organize the resistance against the Turks, the knightly religious orders were reinstituted soon after the fall of Constantinople. In 1469, Pope Paul II and Emperor Frederic III jointly created the Order of the Knights of Saint George of Austria and of Carinthia, charged with defending the borders of Bohemia and Hungary.

This was not the only knightly order placed under the patronage of the saint who had fought against a dragon to free a princess (reminiscent of the mythological hero Perseus delivering Andromeda). There was also an Order of Saint George of Alfama, active during the Spanish Reconquest, and an Order of Saint George of Burgundy.

GERMAN SCHOOL
(ca. 1500)

Enthroning of the First Grand Master of the Knights of Saint George

Regional Museum, Klagenfurt, Austria

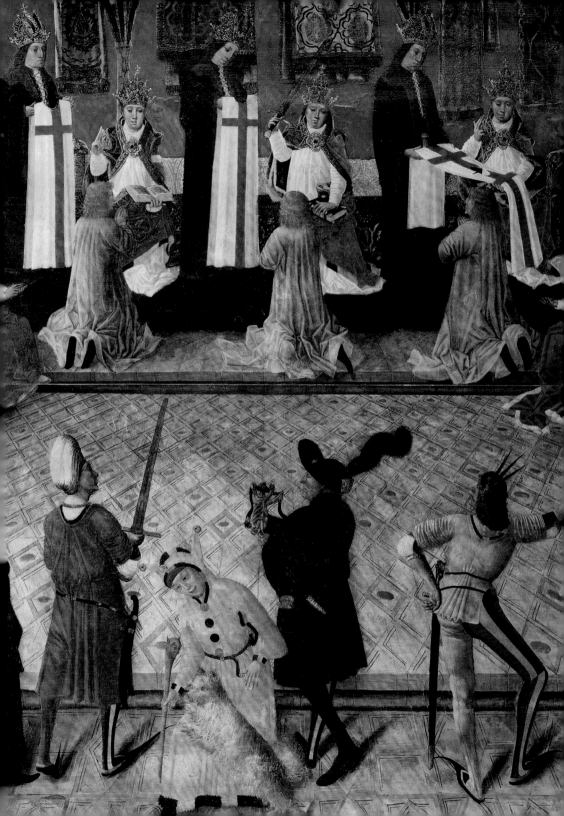

Victory in the South

On January 2, 1492, the Catholic armies of the royal couple Ferdinand of Aragon and Isabel of Castile triumphantly entered a liberated Granada. This was the crowning moment of seven centuries of crusading efforts, to which knights from all of Christendom contributed their share. This is how it came to be that in the ninth century, the nobility of "the nation of Auvergne" in France played an important role in the deliverance of Portugal.

Toledo had been recovered in 1085, thanks to Rodrigo Días de Bivar, known as El Cid. In 1212, the victory of Las Navas de Tolosa opened the way to the retaking of Majorca, Cordoba, Murcia, and Seville. Gibraltar, in its turn, had succumbed in 1309.

All that was left to the Moors was the small kingdom of Granada, which King Boabdil abandoned in 1492.

This territorial reconquest would be followed by an offensive of another kind: the religious reunification of the people of Spain. Jews and Muslims were mercilessly chased out of the kingdom or ordered to convert.* And the Inquisition was there to track the false *conversos*. Thus, it was customary to send acolytes out to the streets on Friday evenings and Saturdays, to note which chimneys did not discharge any smoke, a sign that those within practiced the Jewish Sabbath.

Two stern verses of Victor Hugo denounce this practice: "Would you then demand that the Jews of Toledo be happy to be baked alive in ovens?"

Jusepe Ribera
(1591–1652)

The Capture of Granada

Cathedral of Burgos

* Queen Isabel granted safe conduct to Jews en route to leave Spain. — *Trans.*

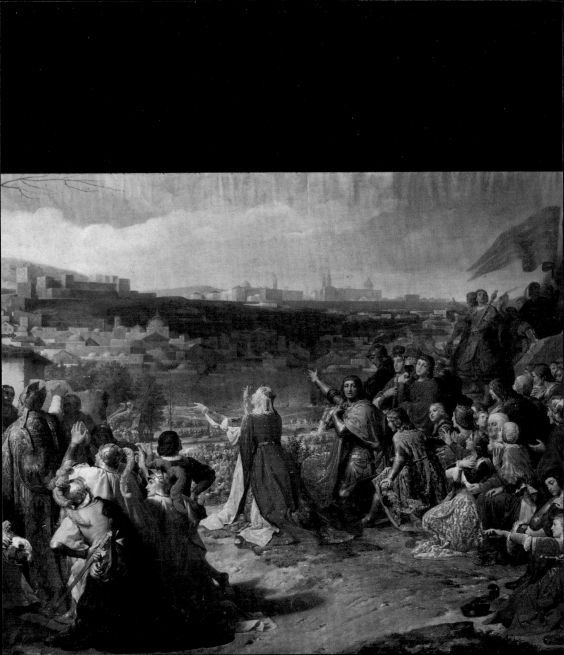

The First Mission to America

It is said that the first action Christopher Columbus and his crew took upon disembarking on a small island of the Bahamas, on October 12, 1492, was to celebrate Mass. This is but a pious legend. It is true that at the first sighting of land after more than a month's journey across the ocean, the sailors intoned the Salve Regina; true also, that Columbus immediately baptized the island with the name of "San Salvador." But there was no Mass, simply because no clergy had wanted to join the expedition.

Sailing westward, Christopher Columbus counted only 95 crewmen aboard his three vessels: the Niña, the Pinta, and the Santa Maria. The majority of these crewmen were galley men, and the total included about 30 newly converted Jews.

Nonetheless, Columbus immediately made religion ubiquitous through the names he gave the islands he discovered.

The first Mass did not take place until a year later, on the occasion of the second expedition of the Genovese seaman, who was now the "Admiral of the Ocean Sea." This time, among the 1,500 men journeying in 17 caravels, there was no shortage of priests.

PARAMOND
BLANCHARD
(1805–1873)

*The First Mass in
America*

Musée des Beaux-
Arts, Dijon

Vain Things Go Up in Flames

Italy was not spared the moral crisis that beset the church at the end of the fifteenth century and that would lead to the Wars of Religion. In the small republic of Florence, a Dominican friar by the name of Girolamo Savonarola seduced the people with his inflamed preaching. He denounced the decadence of the papacy, the lack of morals among the clergy, as well as the arts so patronized by the prince of the city, Lorenzo de' Medici the Magnificent. After his death in 1492, the Medici were chased out of Florence; Savonarola seized power, and an implacable religious tyranny fell upon the city.

On February 7, 1497, Savonarola held a grand burning of "vain things" in the main piazza of the city, publicly casting into an immense bonfire the works of Dante, Petrarch, and Boccaccio, as well as musical instruments, playing cards, jewelry, wigs, and nonreligious paintings.

Among the spectators approving this *auto-de-fé* was Sandro Botticelli, the painter who had revived the use of pagan themes in art with his *Spring* and *The Birth of Venus*. Coming under the influence of Savonarola, he renounced his errors and dedicated himself to religious art and historical compositions that indirectly celebrated the clerical republic of the Dominican friar.

The artist would survive the preacher by 12 years. Abandoned by his French protectors, excommunicated by the pope, contested by the Franciscans, Savonarola ended by being hung and then burned at the stake in 1498, in the very place where he had conducted his *autos-de-fé*.

Italian School
(realized in the
year of the event,
1498)

*The Execution of
Savonarola*

Museo di San
Marco, Florence

The Period of the Borgias

Rodrigo Borgia's career is quite simply prodigious. This nephew of Pope Calixtus III, born in 1431 into the high Spanish nobility, was made a bishop at age 18, a cardinal at 26, and finally ordained a priest at 37 years of age, nearly officially married at 39, and then elected pope at the age of 61, with the name of Alexander VI.

Politically, he was a grand prince. By diplomatic maneuvering, by arms, and also by gold, dagger, and poison, he consolidated pontifical power in an Italy swarming with French soldiery. He, as much as his son Cesare, was the inspiration for Machiavelli's *The Prince,* the model of a ruler who was raised above the yoke of common morality by dint of his function. The escapades of his son Cesare — a cardinal at age 16 and then a peer of France — and of his daughter, the beautiful Lucrezia, married three times by the age of 21 (the first two husbands no doubt died from poisoning), as well as Rodrigo's own mores, contributed to the execrable reputation of the Borgia family.

Nevertheless, he was not a bad pontiff. He organized the evangelization of the natives of the newly discovered lands (which he had divided in advance between Spain and Portugal), and he restrained the abuses of the Inquisition, excommunicating Savonarola in Italy, and, in Spain, deposing the inquisitor Torquemada.

It should also be remembered that his son Cesare hired, as a military engineer, a certain Leonardo da Vinci.

BARTOLOMEO
VENETO
(active between
1502 and 1546)

Lucrezia Borgia

Regional Museum,
Frankfurt-am-Main

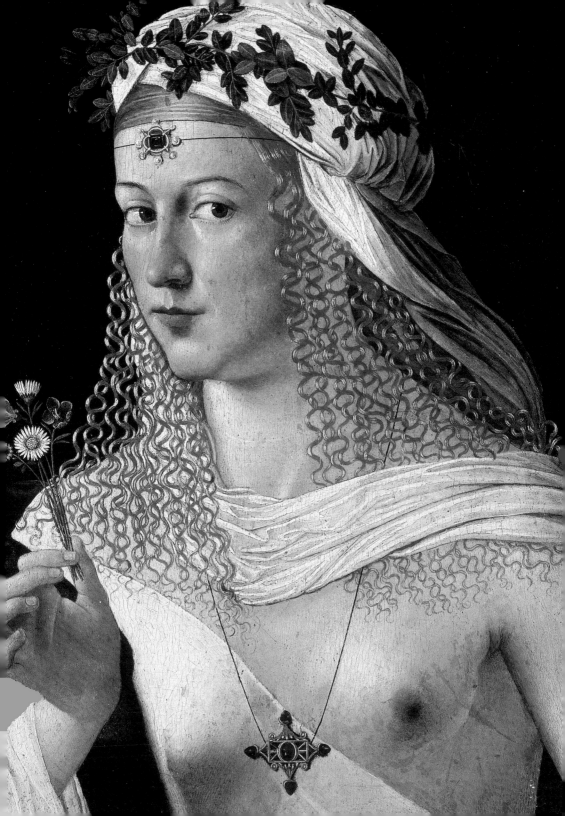

Art in the Service of God

Succeeding Alexander VI — a Spaniard, noble and corrupt — Julius II — an Italian Franciscan from a poor family, honest and pious — ascended to the papal throne. However, they had one point in common: both of them were nephews of popes, which considerably facilitated their careers.

Another similarity between the two was the conviction that pontifical power must be sustained by uncontested temporal rule. Therefore, the new pope continued the same territorial policies of his predecessor, albeit not to assure his own and his family's fortune, but to indirectly reinforce his religious authority.

While ably maneuvering to keep France and the empire at a distance from Italy and the papal territories, he undertook the reform of the secular and religious clergy, addressing their most glaring shortcomings. Conscious of the importance of the arts in communicating and explaining the faith, he also enlisted the services of Michelangelo, Raphael, Bramante, and many other artists, notably launching the construction of the new Basilica of Saint Peter.

Julius II can be considered the father of religious art in modern times, and, in general, one of the most important patrons of the arts in all of history.

Anastasio
Fontebuoni
(1571–1626)

*Michelangelo and
Julius II*

Casa Buonarroti,
Florence

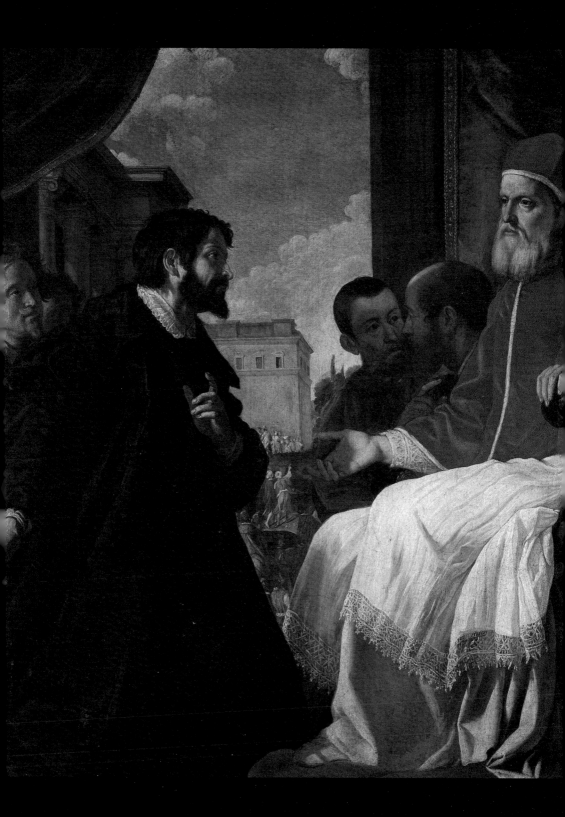

The Concordat with France

In the fifteenth century, a heretofore unknown document somehow resurfaced. It was the *Pragmatic Sanction,* purportedly of Louis IX. This edict interdicted papal taxes collected in the churches of France, and placed the pope under the authority of councils and the councils under the king. The nomination of bishops was the prerogative of the royal ruler, and papal bulls had to be validated by the throne. In 1438, Charles VII revived these providentially discovered decrees, revising the *Sanction,* and further emphasizing the Gallicanism of the church in France.

However, Francis I, inhibited by his Italian expeditions, signed the Concordat of Bologna with Pope Leo X, in 1516. The document reinstated papal taxes, gave the pope the right to veto nominations of bishops made by the king, and recognized the preeminence of the pope over councils.

In our day, all that might seem innocuous. However, Francis I experienced great difficulty in getting the French parliament to endorse the concordat, largely because of opposition from the University of Paris. The text soon became obsolete; nevertheless, for the Vatican it held an important symbolic value, which artists were charged with celebrating.

GIORGIO VASARI
(1511–1574)

*Meeting between
Leo X and Francis I
in Bologna (1516)*

Palazzo Vecchio,
Florence

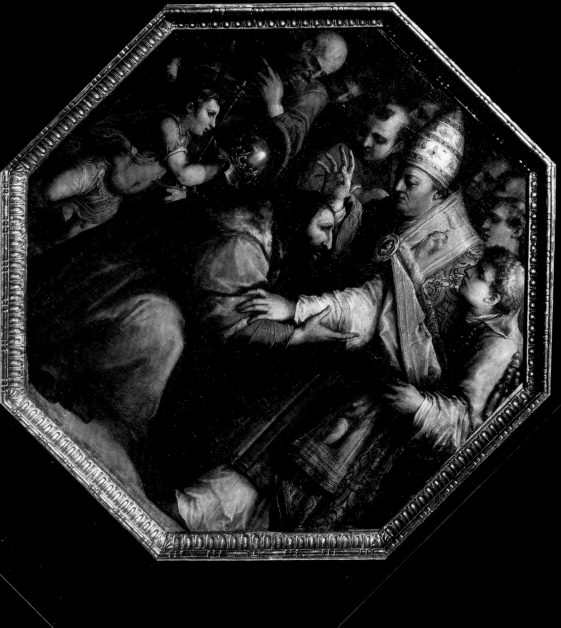

Harbingers of Protestantism

To finish the construction of the Basilica of Saint Peter, Leo X had need of funds. He conceived of a measure to be preached throughout Christendom, exhorting the faithful to contribute, through prayer, penance, and charitable donations, to the erection of a building that was to be the head of all churches. As good works, the monetary contributions would be indulgenced.* However, corrupt clergy capitalized on this papal concession and perpetrated gross abuses from which their own pockets benefitted. There were even systems of fees drawn up, according to gravity of sin. The commotion and scandal over this state of affairs were immense. Criticism of corrupt and pleasure-seeking clergy was already a long-standing tradition, illustrated by François Villon, the fifteenth century French poet and vagabond:

> Sur mol duvet, assis un gras chanoine
> Lèz un brasier, en chambre bien nattée;
> A son côté gisant Dame Sidoine
>
> [Upon a plush down comforter, there sat a fat canon (cleric)
> close to a fireplace, amid walls nicely decked with tapestry;
> at his side there lay Madame Sidoine]

However, this time the criticism was directed at the very head of the church.

The prevailing opinion of the public at the time is aptly captured in Hieronymus Bosch's *The Hay Wagon*. Illustrating the Flemish proverb, "The world is a hay wagon where each takes what he can," the painter shows the greats, pope and emperor, tranquilly coming to help themselves; nuns, representing the clergy, in their convent awaiting the delivery of hay; and the impoverished populace pathetically engaged in pillaging and mutual assault.

HIERONYMUS
BOSCH
(ca. 1450–1516)

The Hay Wagon

Monastery of
El Escorial, San
Lorenzo de El
Escorial, Spain

* An indulgence is the remission of the temporal punishment due to sin, which applies only after repentance, confession of sin, and penance is performed. — *Trans.*

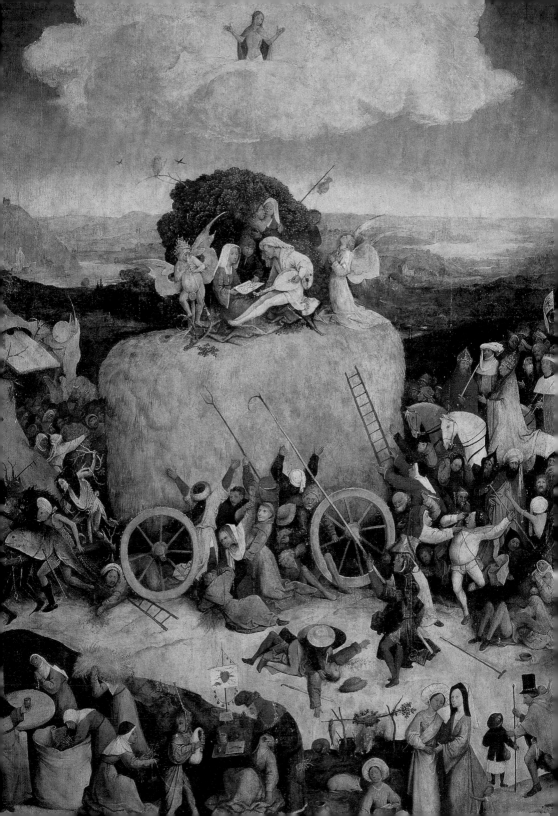

The Theses of Martin Luther

Attached to the door of the church in Wittenberg, Saxony, 95 theses appeared on October 31, 1517. They were the work of a professor of theology of the local university, one Martin Luther. A friar, Luther belonged to the order of Augustinians, traditional rivals of the Dominicans, and it was a Dominican, Johann Tetzel, who preached Leo X's indulgence in Luther's diocese of Brandenburg.

The debate over indulgences was an opening through which Luther unleashed a radical and overriding challenge to the church and its dogmas, calling into question the authority of the pope, purgatory, the cult of saints, confession, transubstantiation, monastic vows, and so on.

As a result, he was condemned, excommunicated, and his writings burned. However, the protection he received from the Elector of Saxony allowed him to stay at liberty, rapidly amass followers, and, in his turn, burn the bulls issued by the pope.

Seeking to resolve the crisis, Emperor Charles V convened a diet in Worms, to which Luther came bearing a safe-conduct. He refused to retract and, once back in Saxony, continued to preach his doctrines. Soon the nobility and rulers of Brandenburg, Hesse, the Palatinate, Franconia, Denmark, and Sweden joined the ranks of the Reformation. The breadth of the movement was such that in 1524, and then again in 1532, the very Catholic Charles V had to concede liberty of conscience in the territories won over by the new faith.

PAUL THUMANN
(1834–1908)

*Luther at the Diet
of Worms*

Warburgschloss,
Eisenach

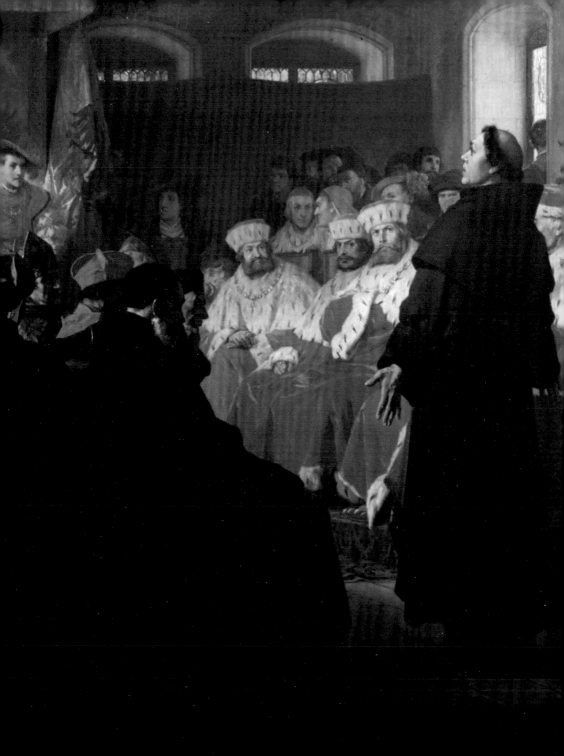

Evangelization of the New World

In 1519, Hernando Cortés landed on the coast of Yucatan, in the Aztec Empire, with 500 men, 16 horses, and 2 priests. With the same passion they felt for seeking gold, the conquistadores immediately set about destroying idols. One of Cortés's first gestures was to gouge the eyes off the statue of a pagan god, even while he was being received as a guest in Mexico.

For evangelization is often inseparable from colonization, as aptly encapsulated by the battle cry of the Portuguese conquistadores: "Christ and spices!" What can be said is that the enterprise was carried out with élan and energy, for submission to the conqueror, one's king, one's pope, and one's God were all and the same in the eyes of the newcomers, whether they were in arms or in habits.

The Franciscans and Dominicans, who were dispatched very early in great numbers to the New World by Spain, were no less fervent in conducting their missionary work, desirous of spreading the faith. And the conversions were much more sincere, profound, and occurred much more quickly than the "Black Legend" — propagated by France and England beginning in the seventeenth century — would have it.

NICOLAS
RODRIGUEZ JUAREZ
(1666–1734)

*Baptism of
an Aztec by a
Dominican*

Museo Nacional de
Historia, Mexico

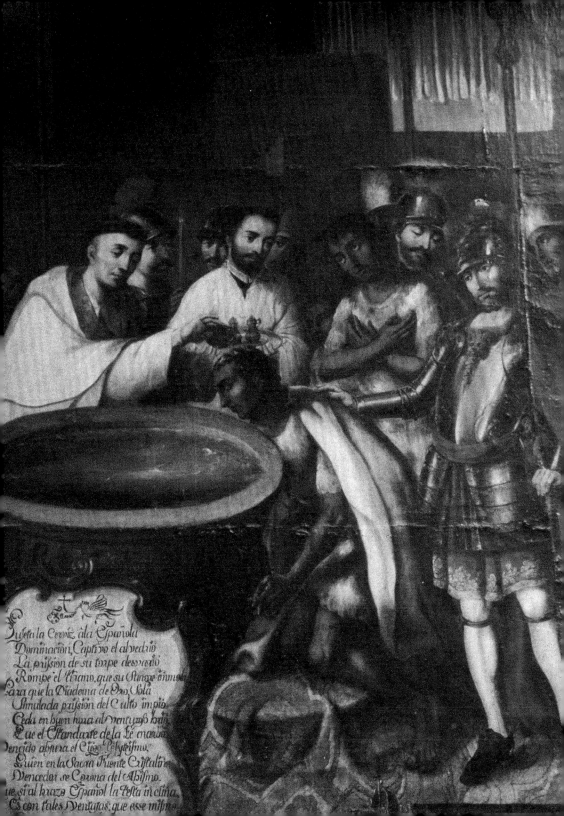

Sujeta la Cerviz, à la Española
Dominación, Captivo el alvedrio
La prission de su imperio desvarió
Rompe el Tirano, que su Sangre inmola
Para que la Diadema de Oro sola
Simulada prission del Culto impio
Ceda en buen hora al Venturoso brio
Que el Estandarte de la Fè enarbola
Vencido abjura el Ciego Polytismo
Quien en la Sacra Fuente Cristalina
Vencedor se Corona del Abismo
Que al brazo Español la Testa inclina
Es con tales Ventajas, que esse mismo

The Sack of Rome

Even a very Catholic sovereign ruler cannot always be selective about his soldiers. Thus, for his campaigns in Italy, Charles V recruited troops from all his domains: Spain, Italy, and Germany.

In 1527, this heterogeneous army laid siege to Rome, under the command of a Frenchman, Duke Charles of Bourbon, who died at the beginning of the assault. Thus left to themselves, the soldiers pillaged the city for eight consecutive days. Rape, massacre, destruction... when it was all over, the victims numbered more than 15,000. Even worse, the Protestant German mercenaries organized a parody of a procession below the walls of the Castel Sant'Angelo where Pope Clement VII had taken refuge, chanting: "Vivat Luther pontifex!" ("Long Live Pope Luther"). Actually, Luther had nearly 20 more years to live.

For the artistic patrimony of Rome, it was a catastrophe equal to the fifth century barbarian sack. Architectural and pictorial works were vandalized, and all religious artifacts — reliquaries, monstrances, ciboria, and precious caskets — disappeared in the turmoil.

It is understandable that the German Protestants would have no scruples about laying hands on the objects of what they considered an abominable cult, but they were not the only ones. According to a witness of the pillaging, "the Germans were atrocious, the Spaniards, ferocious, and the Italians even worse."

GERMAN,
ANONYMOUS
(ca. 1527)

*Georg von
Frundsberg, Leader
of the German
Mercenaries*

Truppen-
kameradschaft

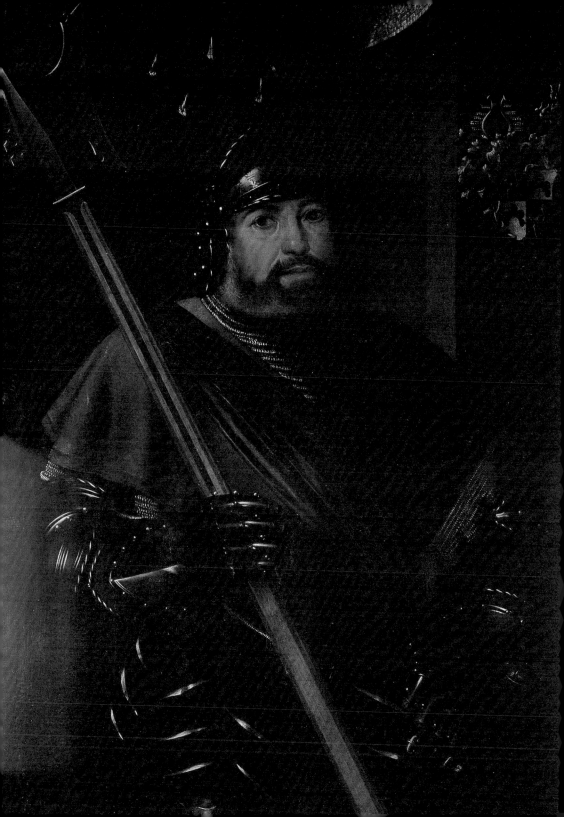

The Crowning of Charles V

In his struggle against the Holy Roman Empire, Pope Clement VII formed the Holy League of Cognac, rallying around his pontifical states a few Italian princes, the king of France, and the king of England. As with the majority of this pope's initiatives, this measure ended up turning against him and the church. Specifically, he was unable to forestall the sack of Rome, despite promising the emperor a ransom of 100,000 ducats.

The price he had to pay to be reconciled with Charles V was even higher. In 1530, Clement VII consecrated the emperor in Bologna, with the iron crown that symbolized Italy.

Already, as Holy Roman Emperor and King of Spain, Charles V was truly at the head of the kingdom "where the sun never set." And he always put his power at the service of his religion, whether promoting the conversion of natives in the Americas, fighting the schism of Luther as far as was possible, or conducting a crusade in Tunis against barbarian pirates — from where he returned in 1535 accompanied by 20,000 Christian slaves that he had set free.

The end of his life was even more pious. He abdicated in 1555 in order to retire to a monastery and dedicate himself to the salvation of his soul. He went as far as having his funeral Mass celebrated two days before his actual death so that he could assist at it in person.

Marco Vecellio
(1545–1611)

The Peace of Bologna

Palazzo degli Dogi, Venice

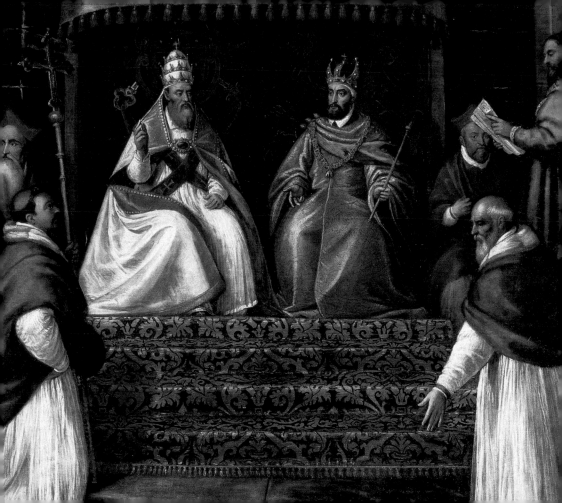

The Apostle of the Indians

Colonists from Spain never doubted that the natives of America had souls, the proof of which is that they did everything to have them baptized. However, there was a question of whether the natives were a people still in infancy, which may have justified them being kept under supervision. This was the point of a debate held in Valladolid in 1550 at the behest of Emperor Charles V, between the Dominicans Bartolomé de las Casas and Juan Ginés de Sepúlveda.

In practical terms, this supervision amounted to slavery, through the system of *encomiendas* by which property granted to a colonist included those who dwelt upon it. Las Casas himself benefited from an *encomienda* before becoming a defender of the natives.

And his defense was heeded. His reports and critiques led Charles V to issue several decrees aimed at restraining the abuses and even to grant the territory of Venezuela to Las Casas so that he could there apply his proposed methods of colonization and evangelization. But the beauty of this effort at pacifism escaped the natives, who only saw the attempt to colonize. The experiment ended in disaster, with the massacre of all the colonists brought by Las Casas to Venezuela.

Nonetheless, his ideas did make their mark, especially one in particular: he proposed that the natives of America be replaced by slaves imported from Africa.

Spanish,
Anonymous
(end of
seventeenth
century)

*Bartolomé de
Las Casas*

Biblioteca
Colombina, Seville

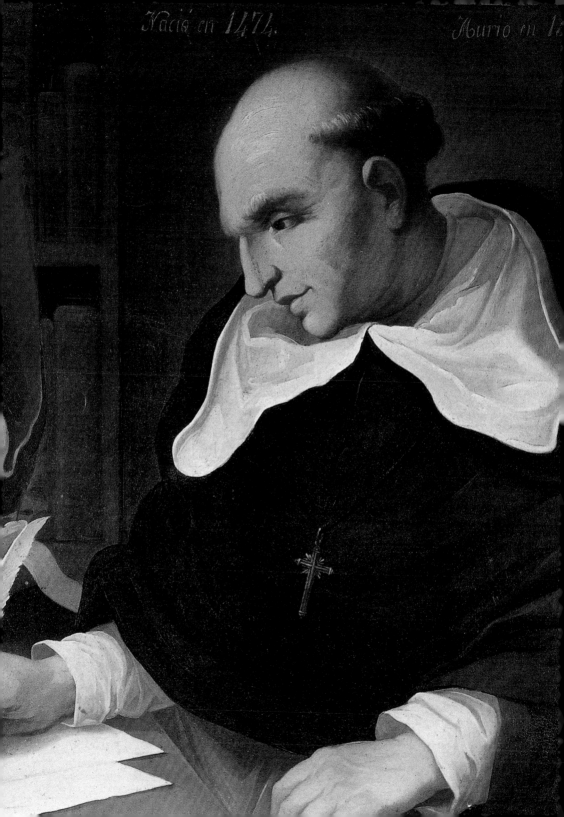

England in Schism

It would have been difficult to imagine a more pious monarch than Henry VIII of England. He usually assisted at three masses a day and, to refute Luther's heresy, he composed a theological treatise, *Assertio Septem Sacramentorum* (*Defense of the Seven Sacraments*), for which the pope granted him the title of "Defender of the Faith."

However, Clement VII temporized when the English king asked him to annul his marriage to Catherine of Aragon so that he could espouse the fair Ann Boleyn. At last, exasperated by the pope's procrastination, the king had his divorce pronounced by the archbishop of Canterbury instead. When the pope excommunicated him, he replied by having Parliament proclaim himself the supreme head of the church in England. Thenceforward, Henry would attack Catholics faithful to Rome with the same zeal he had shown in pursuing the followers of Luther.

It was only the first divorce that posed any difficulties to King Henry. Four years later, he had Ann Boleyn beheaded for adultery, married Jane Seymour (who died in labor), then Anne of Cleves (repudiated for her homeliness), Catherine Howard (beheaded), and, finally, Catherine Parr, who survived him.

WILLIAM POWELL
FRITH
(1819–1909)

Henry VIII and Ann Boleyn in the Forest of Windsor

Private collection

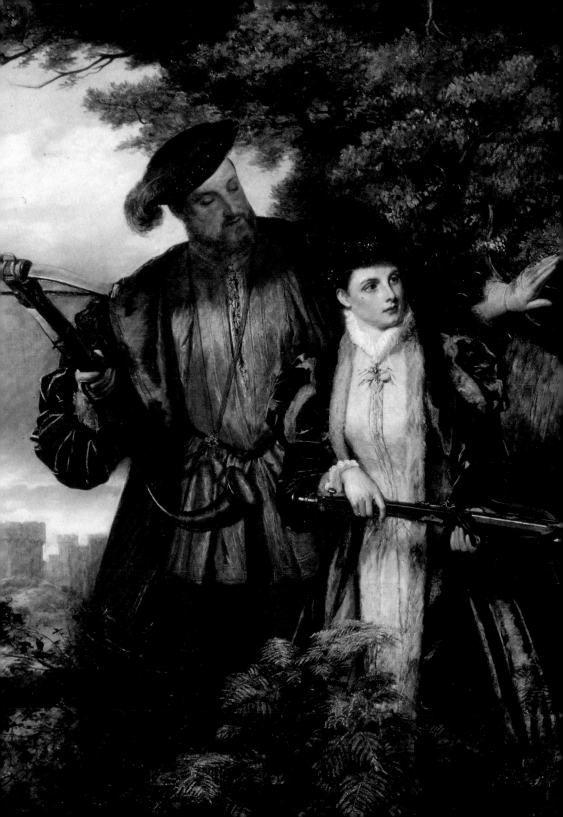

Protestant Intolerance

Ever ready to demand liberty of conscience for themselves, the Protestants also demonstrated intolerance toward those who contested their dogmas. The story of John Calvin and Miguel Servet provides an apt illustration.*

Calvin was a jurist, born in the Picardy region of France. Having converted to the doctrines of Luther, he preached the new faith while introducing some slight changes to what he had received. In France, his followers were called Huguenots. In 1536 he became a theologian in Geneva—which had aligned itself with the Reformation—though he was later banned for his excessive rigorism. He returned some years afterward and before long was exerting absolute authority over the city.

It was at this point that Miguel Servet—a physician from Spain who practiced in Vienne, not far from Geneva—began exchanging letters with him, in an attempt to win Calvin over to his own theories, particularly his rejection of the Trinity.

Calvin denounced Servet, going so far as to send the letters the doctor had written him to the Catholic tribunal in Vienne. Servet managed to escape and began a time of clandestine wanderings, which brought him to Geneva, where he was recognized. Calvin then formulated 39 points of accusation against him, which ultimately led to Servet's being condemned to death. On the eve of his execution, October 26, 1553, the theologian again attempted to bring the physician to repentance, but Servet refused and was publicly burned to death.

* Other accounts of these events depict Calvin's role somewhat differently, indicating that he was reticent to condem Servetus and only did so because he felt his hands were tied. Calvin requested that Servetus be decapitated rather than burned, since that would result in less suffering, but the Geneva Council, which presided over the sentence, refused.

THEODOR PIXIS
(1831–1907)

Calvin and Servet

Die Pfalzgalerie,
Kaiserslautern

The Thomas More Affair

The concurrence of the Reformation and humanism may seem to suggest that the two movements were in league. In reality, humanism in Europe remained largely Catholic, as demonstrated by Erasmus's prolonged dispute against the positions of Luther. At the end of his life, the scholar of Louvain was actually offered the cardinal's hat by Pope Paul III.

Another great representative of humanism affirmed his fidelity to the church even onto the scaffold. Philosopher, lawyer, and writer, Thomas More was held in high esteem by Erasmus who described him as "a man such as for centuries the sun has not seen as loyal, as frank, as devout, and as wise."

Unfortunately for him, he was also a high ranking politician. Elected to Parliament at a very young age, More was subsequently admitted to the Privy Council of King Henry VIII, who appointed him his Grand Chancellor in 1529. Three years later he resigned—faithful to the Catholic Church, he would not act upon the monarch's desire to annul his marriage. In 1534, More refused to take the oath recognizing the king's authority over the church, which earned him the death sentence for high treason.

He was beheaded the following year. Four centuries later, in 1935, the Roman Catholic Church declared him a saint.

ANTOINE CARON
(ca. 1521–1599)

*The Execution of
Thomas More*

Municipal
Museum, Blois

"Perinde Ac Cadaver"

On August 15, 1534, two Basques and a Savoyard studying theology in Paris decided to create a new religious order. They were Ignatius of Loyola, Francis Xavier, and Peter Fabre, and the order they established, the Society of Jesus, would be recognized by the pope six years later.

The Society was both something entirely novel and yet reminiscent of an ancient institution. Loyola, who had been a military man, conceived of recreating a company of soldier-monks, similar to the old, obsolete chivalric orders. His soldiers would not bear arms, but other than that, all else would be the same: first, discipline, which is the strength of the heavenly armies; then, absolute obedience (*perinde ac cadaver* — "in the manner of a corpse") to the superior of the order, who bore the title of General.

Their evangelizing missionary activities were carried out as expeditions unto the ends of the known world and even beyond. Within the old continent of Europe, they engaged in another type of combat: the fight against Protestantism, no longer wielding the scaffold and stake of old, but through education, through an intellectual offensive, and a methodical occupation of the territory of science.

Occasionally, the military character of the order had the upper hand, for example, in the defense of the "reductions" of Paraguay, a veritable theocratic nation that the Jesuits had established in the heart of South America. And there was the Gunpowder Plot in England, in 1605, when a few Jesuits were purportedly involved in a thwarted conspiracy to blow up the king of England and his Parliament.

GIOVANNI BATTISTA MARIOTTI (ca. 1685–1765)

Ignatius of Loyola before the Pope

Galleria dell'Accademia, Venice

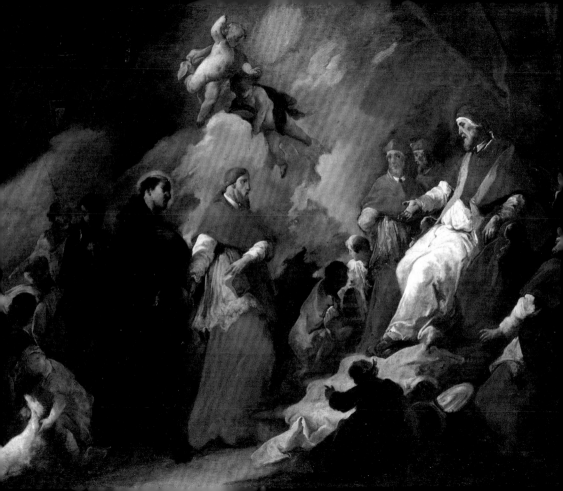

The Council of Trent

The Council of Trent was called by Pope Paul III in 1542. Lasting 20 years, its objective was to launch a multipronged counterreform, in response to the challenges posed by Luther and the Protestants.

The council's work was primarily in the area of discipline: the duties of the clergy were strictly defined so as to bring an end to centuries of abuse. Theological problems were also clarified, be it by codifying liturgical rites and the order of Mass, or by defining dogma more exactly.

All manner of forces were mobilized for this great work, including artists, painters, sculptors, and architects. The effort marked the launch of the Baroque style, which sought to display all the attractive beauty of the true faith in face of the iconoclastic rigorism of Protestants.

Thus, the influence of the Council of Trent went beyond the boundaries of religion, leaving its imprint, above all, in culture. This is obvious still in museums, of course, but also throughout the Christian world, in the physiognomy of its towns.

Swiss,
Anonymous
(1769 copy of a
work painted at
the time of the
Council)

*The Council of
Trent*

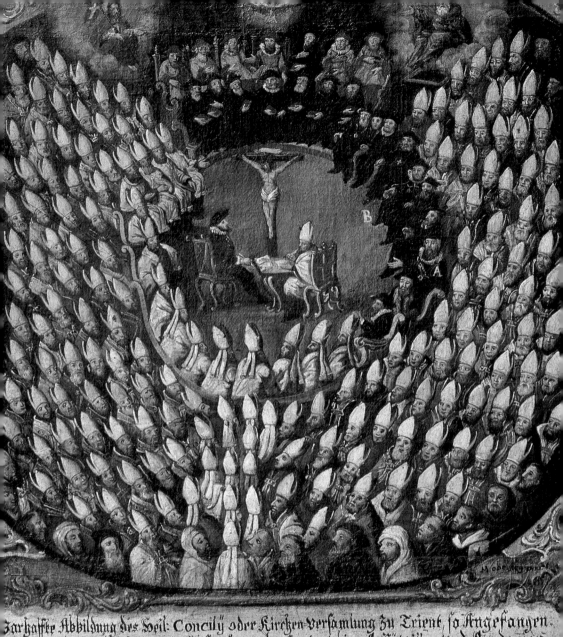

Jarhaffte Abbildung des Heil: Concily oder Kirchen-Versamlung zu Trient, so Angefangen
A° 1545 Vnd geendet 1563. Wie solche Herr oberster Melchior Lussy Ritter Vnd Landaman
als gewester Abgesandter von den 7. Lobl: Chat: Cantonen in seinem Wohnhaus hate
Abmahlen Lassen. Disere Taffel hat Herr Haubtman Felix Leonti Keyser Alt-Land-
aman zu Ehren Vnd gedächtnus Hochermelten Herren Lussis als seines geswesten Uran-
herren Copieren, und in das Capuciner-Convent Vbersetzen Lassen A° 1769.

A Ist das orth wo Herr Lussy in dem Concilio Den sitz gehabt, der Keyserliche Frantzösisch
portugösische, und Venetianische Abgesandte hate den Vor Rang, Wie B. die Andere Fü
aber nach ihme, der Spanische Aber saße bey Dem Herzen Secretario gantz Allein A

The Reformation's Theoretician

He was baptized Philipp Schwarzerd, but to show that he knew Greek, he renamed himself Melanchthon, a translation of his surname ("black earth"). A professor and magistrate, Melanchthon lived in Wittenberg under the shadow of Luther; however, it would be difficult to determine which of the two had the greater influence on the other.

Where Luther was inflamed and polemical, Melanchthon was discreet and peaceful. He repeatedly tried to reconcile the positions of the Reformation with those of the church, but in vain.

Despite his true mildness, Melanchthon played a key role in effecting the divorce of the Reformation and the papacy. He composed the *Augsburg Confession* in 1530, the founding document of Lutheranism, followed by an abundance of works that codified Protestant dogma, as well as notes, papers, and letters which he sent by the thousands to princes and men of letters in all of Europe.

Styled "the professor of Germany," he was immensely popular in his country, as testified by his numerous portraits, particularly those by Cranach and Dürer.

Lucas Cranach,
the Elder
(1472–1553)

*Philippe
Melanchthon*

The Voyages of Francis Xavier

Having been among the very first companions of Ignatius of Loyola, Francis Xavier was 35 when he set sail for Goa, a Portuguese trading post on the coasts of India. With this journey, he embarked upon an extraordinary voyage of more than ten years, preaching the Gospel to Indian rajahs, Japanese daimyos, Tamoul pearl fishers, the Malays of Malacca, the Ambonese of the Moluccas, to merchants and pirates of all nationalities, Muslim seamen and Buddhist monks of Kyoto, to princes and lepers. He died in 1552, on a small island off the coast of China, which he had hoped to reach some day.

The accounts that Saint Francis Xavier regularly sent to Rome quickly made him a celebrity. His adventures in unknown countries fascinated and enthused the public, giving rise to legends then recounted in numerous paintings. Rubens and Poussin depicted him bringing the dead back to life. He also inspired Rembrandt and Van Dyck, among others.

Giuseppe Laudati
(1672–1737)

*Francis Xavier
Baptizing an
Indian Queen*

Galleria Nazionale
dell'Umbria,
Perugia

The Miracle of Lepanto

In September 1570, the Turks seized the island of Cyprus, which until then had been a protectorate of Venice. There was great concern that the Ottomans, already masters of the Balkans and Northern Africa, would next direct their conquests toward Italy, and thus, the heart of Christendom.

Faced with such a prospect, Pope Pius V decided to launch a crusade to recover Cyprus. While he was supported in this by Venice, a principally interested party, the rest of the Catholic world was loath to mobilize for the effort. The only country to respond to the Holy Father's appeal was Spain.

Nevertheless, this would suffice. On October 7, 1571, the two fleets confronted each other: the Turks about 34,000 men strong, the Christian numbering about 28,000. The battle took place at the mouth of the Gulf of Corinth, not far from Actium, where Antony and Cleopatra's fleet once faced Octavian Augustus, or from Navarino, where the French, British, and Russian fleets would challenge the Turco-Egyptian squadron in 1827.

Under the command of Prince Juan of Austria, the Christian victory was decisive and complete, and the European ambitions of the Turks were deflected for a few more centuries.*

The event had enormous repercussions, as directly testified by art and indirectly by literature. Having lost his left arm in the fight, a Spanish seaman who could no longer sail decided to dedicate his time thenceforth to writing. His name was Miguel Cervantes.

PAOLO VERONESE (*alias,* Paolo Caliari) (1528–1588)

The Battle of Lepanto

Galleria dell'Accademia, Venice

* Concurrently with launching a crusade, Pope Pius V issued a request that the Christian world pray the Rosary for that intention. Thus, October 7 is observed as the feast of Our Lady of the Rosary—previously called Our Lady of Victory—in the Catholic liturgical calendar. — *Trans.*

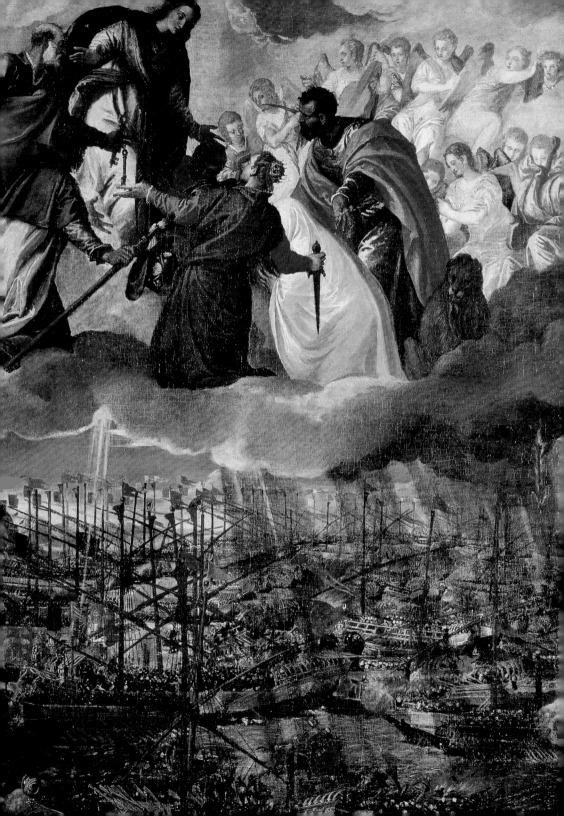

The Saint Bartholomew Massacre

It was a beautiful occasion in France, at first. The marriage of the sister of King Charles IX to Henry of Navarre (the future Henry IV of France) in August 1572, brought to the very Catholic city of Paris all the Huguenot nobility of the kingdom, companions of the husband-to-be.

The atmosphere grew heavy, however. On August 22, Admiral de Coligny, the head of the Protestant faction (but yet a councilor to the king) was wounded in an assassination attempt. Advised by the queen mother, Catherine de Medici, and the Catholic party, the weak Charles IX consented to putting an end to the Huguenots.

The conspiracy was executed in masterly fashion, starting on August 24 (the feast of Saint Bartholomew). At the sound of the alarm bell, the king's guards set upon homes and hotels where Protestants were lodged; Coligny's throat was slit and around 200 Huguenots of the nobility were assassinated. A wounded Huguenot took refuge in the Louvre Palace, in the bedchamber, in fact, in the very bed of the young newlywed princess. Queen Margot, as she would be called in the due course of history, described in her memoirs how she saved the life of an unknown wounded man, with the acquiescence of the captain of the royal guard who had a good laugh at the sight.

As to the very Catholic Parisians, they took advantage of the occasion to rid their town of any Protestant presence. From door to door, from town to town, the massacre spread to claim an estimated 30,000 victims.

The young husband, Henry of Navarre, escaped by abjuring (only very temporarily) his religion. His life, as well as Paris, was certainly worth a Mass.*

ALEXANDRE-
ÉVARISTE
FRAGONARD
(1780–1850)

Scene of the Saint Bartholomew Massacre in the Bedchamber of the Queen of Navarra

Musée du Louvre, Paris

* A reference to his famous comment: "Paris is worth a Mass." — *Trans.*

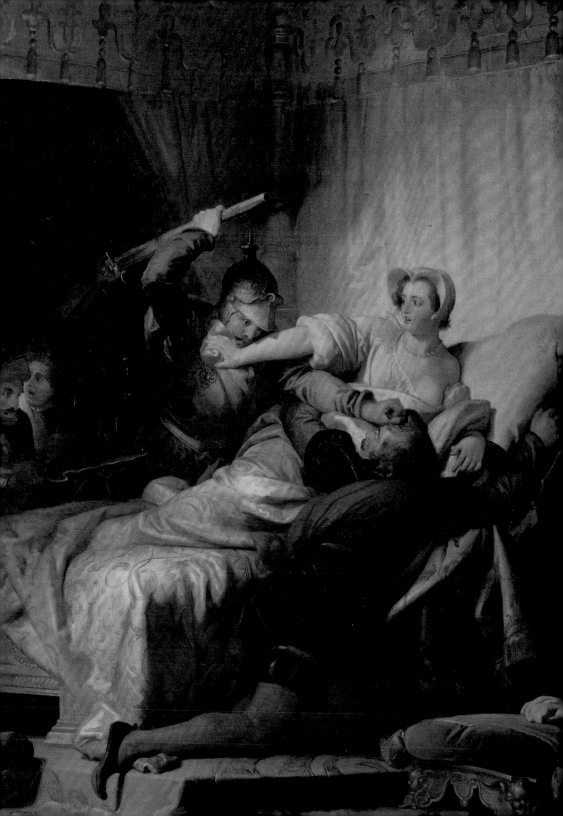

The Third Rome

While Western Europe was being torn apart by religious wars, another expression of Christianity was triumphing in the East. In 1547, Prince Ivan of Moscow imposed his will on boyars and religious dignitaries, having himself crowned tsar of all Russia.

There followed a reign marked by victories and follies. At the head of his Cossacks, Ivan the Terrible conquered the khanate Muslims of Kazan, Astrakan, and Crimea; pushed north up to the Baltic Sea, where he clashed with Catholic Poles and Protestant Swedes; then passed on to the Urals in the east, opening the wide spaces of Siberia to Christian Orthodoxy.

Out of the convulsions of an erratic and belligerent regime, a "third Rome" was born, which saw itself as the heir of Byzantium. Thenceforth, Moscow would be the center from which the Orthodox religion would spread.

Absorbed in its overseas conquests and its wars between papists and Protestants, Western Europe did not notice the rise in power of this other pole of Christianity.

PIOTR ISAAKOVICH
GELLER
(1862–1933)

Ivan the Terrible's
Corpse Consecrated
a Monk

The Russian
Museum,
Saint Petersburg

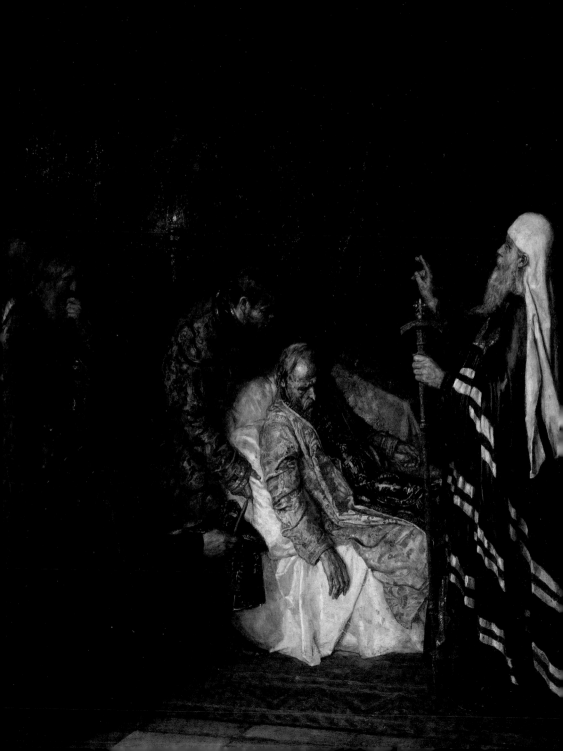

Catholics against Catholics in France

In an attempt to pacify his kingdom, Henry III of France extended an offer of peace to the Huguenots through the Edict of Beaulieu, the result of which was an uprising of Catholics. The most intransigent among them created a holy union, commonly called the Holy League. Its leader, the Duke de Guise doubtlessly desired to defend Catholicism, but he also wanted, at least as much, to seize the royal throne.

Ever trying to reconcile the unreconcilable, Henry III declared himself the head of the League, seeking to bring it under his control. In 1588, the response from the Duke de Guise and his fellow League members was to conduct a day of rioting and barricades, which succeeded in chasing the king from his capital. The royal reply to this was the assassination of the Duke de Guise in Blois at the end of that same year. However, the League still held Paris and other cities under its control.

The following year, the Dominican friar Jacques Clément killed Henry III, and total confusion ensued. Henry IV, Prince of Navarre and the legitimate successor of the murdered king, took to arms, while the League, which was supported by Spain and the papacy, proclaimed Cardinal Charles de Bourbon the new king, under the name of Charles X.

Little enthused by the idea, the cardinal preferred to recognize the legitimacy of Henry, his nephew, but the League adamantly refused any compromise. Thus, the war of religion led to a crisis of succession in France that would only be resolved by recourse to arms.

FRENCH,
ANONYMOUS
(sixteenth century)

*Procession of the
League at the Grève*

Musée Carnavalet,
Paris

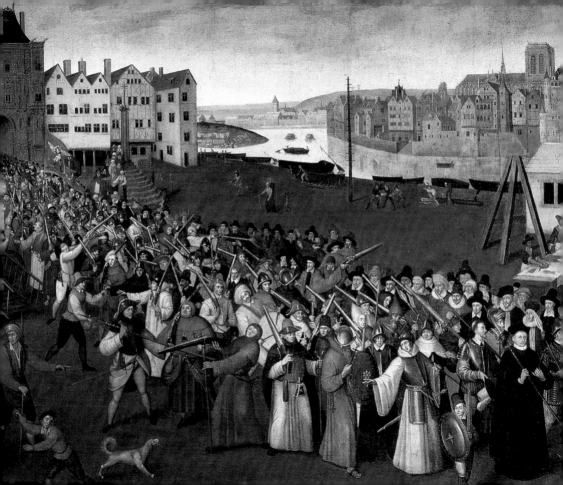

The Defeat of the Armada

At the same time that he supported the Holy League in France, Philip II of Spain hoped to bring an end to the schism in England. To be sure, there were religious motives for this — Elizabeth, queen of England, had just put her Catholic rival, Mary Stuart, to death. But there were also other reasons. The English helped sustain the revolts in the Spanish Netherlands, and Francis Drake's ships challenged Spanish supremacy in the Atlantic and the New World.

Still buoyed by its victory in Lepanto 17 years earlier against another enemy of the faith, the Spanish navy began to prepare for an invasion of England: 30,000 men were gathered upon 130 ships. The fleet would also transport an additional 20,000 soldiers who waited in the Netherlands.

When the Armada called in at the port of Calais, the English launched a group of fireships against it, small boats filled with explosives and combustibles. Panic broke out. Constrained to leave the port in order to avoid going up in flames, the Armada came under the fire of cannons from English vessels armed with heavier artillery. A storm finished off the work begun by the English, and the Armada sunk, ships and men, in the sight of Ireland.

HENDRIK
CORNELISZ VROOM
(1566–1640)

Battle between the Invincible Armada and the English Fleet

Tiroler
Landesmuseum
Ferdinandeum,
Innsbruck

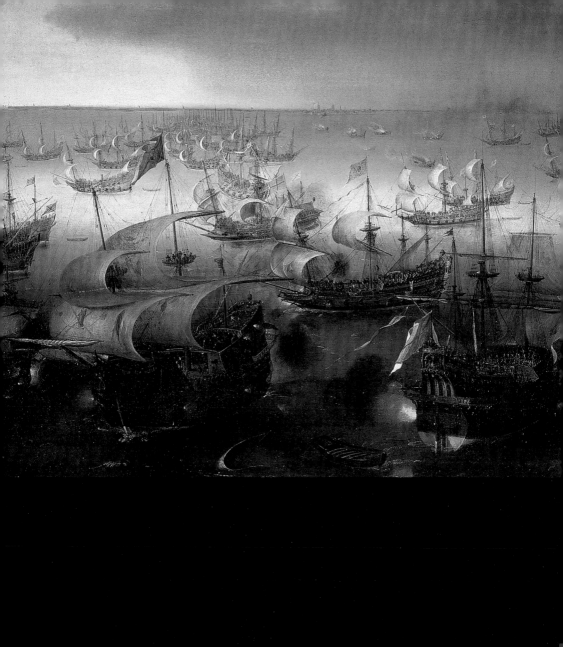

"Paris Is Worth a Mass"

There was a long period of hesitation before Henry IV came to a decision. Not until four years after the death of his predecessor did he ask, at Saint-Denis, to be received into the Catholic Church. In the meantime, he had several times defeated the Holy League's army, but he had also understood that this war of religion would not come to an end until he was recognized as the legitimate monarch by the Catholic majority. And since the city of Rheims was under control of the League, it was at Chartres that he had himself consecrated as king of France, on February 27, 1594.

This abjuration of Protestantism must not have cost him much. He had already ostensibly joined the Catholic faith at the time of the Saint Bartholomew massacre, when he was threatened with: "The Mass or your head!" But converting too early would not have served him well. First, he had to dilute the military power of the de Guise family and the League. Once this had been accomplished, his conversion came as a good gesture toward the city of Paris, which, knowing it could not bear the siege for much longer, welcomed the pretext for finally opening its doors to the king.

The enthronement of this monarch who had one foot in each camp put an end to the civil war. In 1598, the Edict of Nantes reinforced the peace. However, for Henry IV, guaranteeing religious liberty to the Huguenots was not enough; he also granted them 60 safe havens with Protestant garrisons, "for the space of eight years."

François Gérard
(1770–1837)

*The Entrance of
Henry IV into Paris*

Musée National du
Château, Versailles

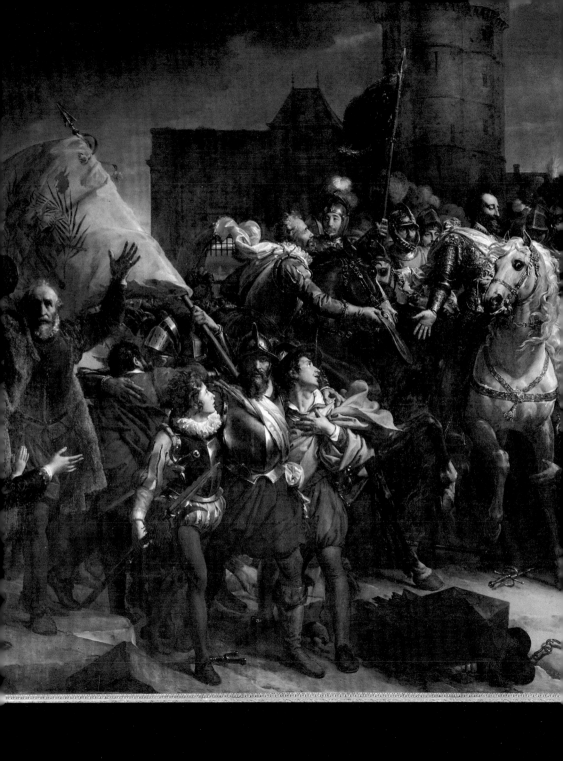

The Counter-Reformation

In conformity with the intentions of the Council of Trent, the Catholic Church mobilized all its intellectual forces to counter the reformed religion. In 1543, three years after the Society of Jesus had been officially recognized by the Holy See, it received a young seminarian from Nijmegen, the Netherlands — Peter Kanjis, or Canisius in its Latinized form.

An intellectual of the highest rank, he wrote a catechism that quickly became authoritative in the Catholic world. Neither was this formidable dialectician hesitant about engaging the adversary's camp in debate. At the Diet of Worms of 1557, he so ably used the arguments of the Protestant theologians that he succeeded in pitting one against the other.

To be sure, this did not constitute a Catholic victory, but it nonetheless led to a weakening of the Protestant position. Such a tactic would be reapplied in the course of the centuries, with the Catholic Church always claiming its unity as an argument against the divisions in the Protestant world.

Peter Canisius was also active in another field favored by the Jesuits: he created ten schools in Germany for the instruction of the youth.

Beatified in 1864, Peter Canisius was canonized and declared a doctor of the church in 1925.

FLEMISH,
ANONYMOUS
(mid-seventeenth
century)

*Saint Peter
Canisius*

Private collection

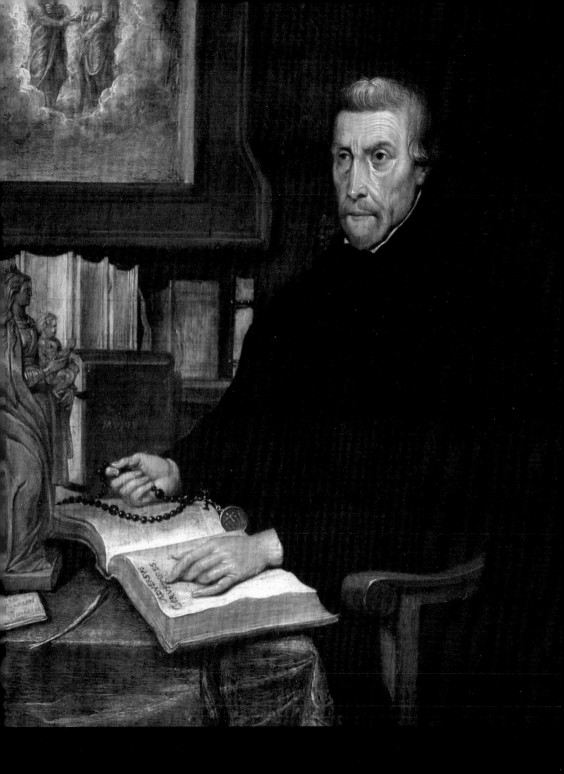

Peace Revisted

The political compromise effected by the Edict of Nantes guaranteed liberty of conscience, but a liberty that was strictly circumscribed. Protestant worship and practice was only authorized in the locations where the Huguenots were a majority of the population, as well as within the domains of Huguenot nobility. It was forbidden in cities where bishoprics had their sees, such as Paris.

Thus, in the very Catholic city of Nantes, where the edict was signed — the last bastion of the League — Protestant worship was forbidden except in four places.

The city of Lyons was a special case. While the town had been taken by the Huguenots in 1562 and temporarily made the capital of Protestantism in France, the surrounding province remained staunchly Catholic. The Temple of Paradise, one of the first examples of Protestant architecture, was erected two years later in the city. But when Lyons was seized by the League, it experienced its own version of the Saint Bartholomew massacre, known as the Lyonnaise Vespers.

The Temple of Paradise, destroyed and then rebuilt, functioned until the Edict of Nantes was revoked.

FRENCH,
ANONYMOUS
(seventeenth
century)

*The Paradise,
Protestant Temple
in Lyons*

Public and
University Library,
Geneva

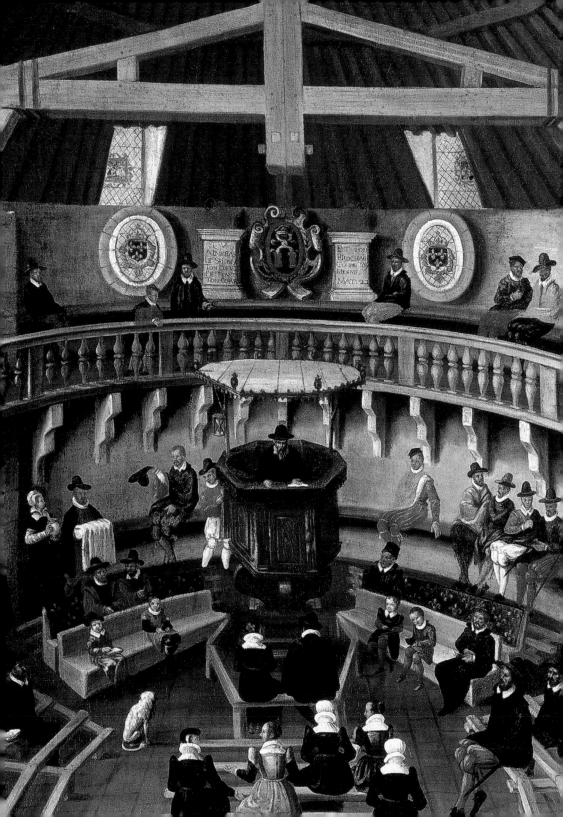

The Siege of La Rochelle

The ambiguity of the situation created by the Edict of Nantes came to a head 30 years later at La Rochelle, a stronghold of the Huguenots off the Bay of Biscay. In 1622, the city practically seceded from France, calling the English to its aid, which prompted the royal government to lay siege to it.

In fact, a double siege was underway; while the Protestants were besieged in their city of La Rochelle, a Catholic contingent in the nearby isle of Ré experienced the same treatment (including famine) from the English in the fort of Saint-Martin. In 1627, the Duke of Buckingham, the favorite of the king of England, blockaded the fort when he landed on the island of Ré, seeking a base from which to support the people of La Rochelle. Three swimmers volunteered to cross the strait between Ré and La Rochelle in order to alert the French royal troops. Only one succeeded.

At the outset of the siege of La Rochelle, a French royal fleet was able to break the blockade at Saint-Martin, replenishing its supplies. Richelieu, who did not want the English to imitate the maneuver he had just executed, ordered a seawall raised in front of the port of La Rochelle, impeding any aid from reaching the city by sea.

When La Rochelle finally surrendered, after 14 months of siege, there were only 5,000 left of the original population of 27,000. This marked the end of Protestant garrisons in France. With the Edict of Alès, Louis XIII withdrew this military concession, while reaffirming religious tolerance. Thenceforth, Protestants would no longer pose a threat to the kingdom.

LE LORRAIN
(*alias,* CLAUDE
GELLÉE)
(1600–1682)

*Louis XIII at the
Siege of La Rochelle*

Musée du Louvre,
Paris

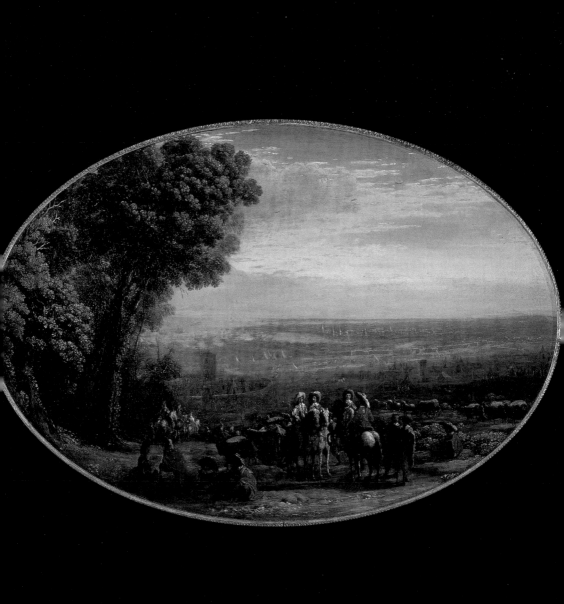

The Trial of Galileo

"Because you held as true the false doctrine taught by some that the sun is the center of the world and motionless, and the earth is not, but moves with diurnal motion; whereas you taught this doctrine to your disciples and wrote about it to the mathematicians of Germany, your correspondents...."

This allusion to German correspondents in the sentence of condemnation pronounced against Galileo on June 22, 1623, is very illuminating. To many, the heliocentric theory appeared to be a new war machine from the Protestant world. In reality, the hypothesis had first been formulated by a pious Polish canon, Copernicus. And Protestants likewise showed violent hostility toward this system, which ruined the geography of Ptolemy, thus, the physics of Aristotle, and therefore, scholastic tradition.

In 1616, Copernican propositions had already been declared heretical by Rome. Because Galileo supported the theories publicly and with great vehemence, he was forced to abjure his position, though no one quite believed the sincerity of his declaration.

Galileo died in 1642. The interdiction against the theories of Copernicus was lifted in 1757; however, the condemnation of Galileo was not formally nullified until 1992.

Joseph Nicolas
Robert-Fleury
(1797–1890)

*Galileo before the
Inquisition*

Musée du Louvre,
Paris

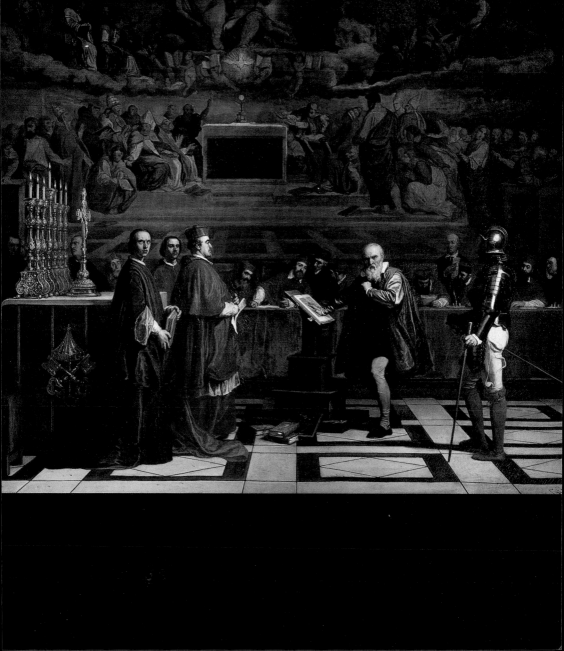

Martyrs of the New World

Christians did not take long to export their theological quarrels to the newly discovered lands beyond the sea. In 1600, Henry IV had granted a monopoly on the fur trade in New France, that is, Quebec, to Pierre Chauvin, a Huguenot. However, 20 years later it was decided that only good Catholics would be admitted to the colony in the New World, and Jesuits were put in charge of evangelizing the natives.

The Jesuit missions enjoyed real success among the tribes allied to the French, the Hurons. On the other hand, the Iroquois, traditional enemies of the Hurons, had the support of Dutch and English Protestants.

Thus, the war over control of the fur trade was compounded by religious war. In 1642, Iroquois in the future state of New York captured and martyred two Jesuits, Isaac Jogues and René Goupil, applying all the refinements of torture of which they were capable. Six years later, fathers Jean de Brébeuf and Gabriel Lallemand suffered the same fate.

The celebration of the missionary martyrs of the Americas, Asia, and, later, Africa was promptly incorporated into religious iconography, as well as into secular art with the development of colonial ideology.

FRANCISCO GOYA
(1746–1828)

*Fathers Brébeuf
and Lallemand
Martyred by the
Iroquois*

Musée des
Beaux-Arts et
d'Architecture,
Besançon

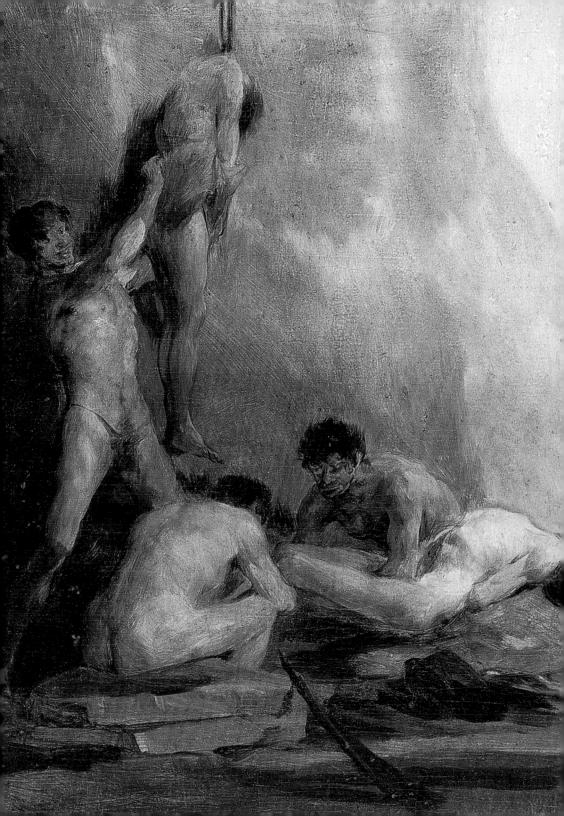

Martyr of the Rising Sun

Thirty years after the passage of Francis Xavier, the church in Japan numbered at least 150,000 faithful in the Nagasaki area, with Jesuit and Franciscan missionaries arriving in ever greater numbers to help minister to the population.

The central power of the country began to take offense at this state of affairs, under the counsel, most notably, of Dutch Protestant merchants desirous of eliminating their competition. Repression was implemented in two phases. At the end of the sixteenth century, the missionaries were expelled and their religion forbidden under penalty of death. Among the first martyrs was Paul Miki, the son of a samurai, who had entered the Society of Jesus and was crucified in 1597. He was the first native Japanese martyr.

Forty years later, an immense rebellion of Catholic peasants broke out in the Shimabara peninsula, with the sack of Buddhist temples and massacre of their monks. It took an army of 100,000 men to quell the revolt, helped by the Dutch, who bombarded the Catholics from their ships.

Following the last massacre, in 1638, Japan closed its borders to any European influence, remaining isolated for two centuries. The one exception to this was a trading post granted to the Dutch in the port of Nagasaki.

JUAN CARREÑO DE
MIRANDA
(1614–1685)

*Franciscan Martyrs
of Japan*

Museo de Santa
Cruz, Toledo

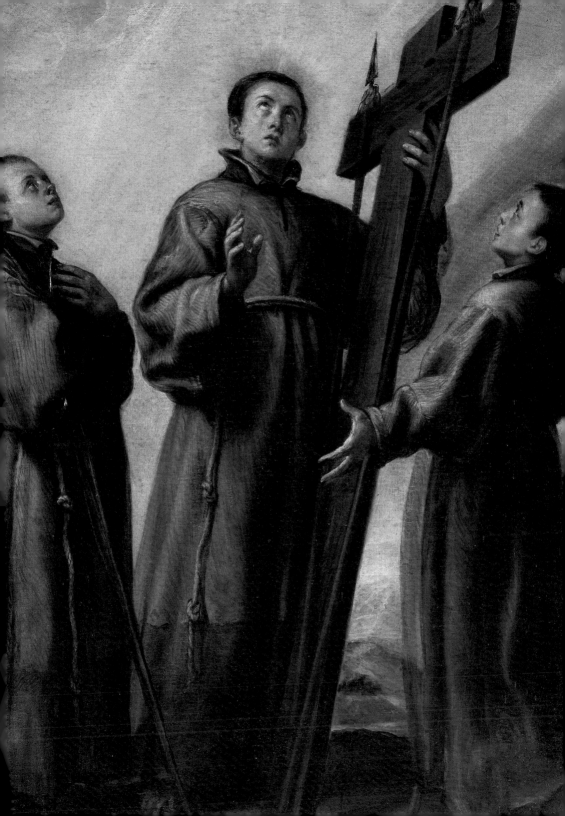

The Mystery of Grace

Rome's response, and in particular, the Jesuits' response, to the Calvinist doctrine claiming that God dispenses his grace only upon a small number of predestined elect, was that the sacrifice of Christ has given grace to all people, leaving to each individual the free will to accept it or not. Nonetheless, basing himself on Saint Augustine, the Catholic bishop of Ypres in France, Cornelius Jansen, developed a doctrine of predestination close to Calvinism.

One of his followers, the Abbot of Saint-Cyran, confessor of the Cistercian nuns of Port Royal, converted them to this doctrine. As a Jansenist, the community's superior, Mother Angélique Arnaud, came to exert an influence that extended beyond the walls of the convent, attracting to its environs the *solitaires,* men of the gentry who founded schools and centers of intellectual formation in competition with the Jesuit schools — the Petites Écoles.

Jansenism was resolutely condemned by Rome. However, its fame endured because of the renown of some of its adepts; first among these was Blaise Pascal, mathematician and a writer of genius, then the painter Philippe de Champaigne; and finally, Jean Racine, formed at the Petites Écoles, who returned to Jansenism after a long period of worldly pursuits.

The Jesuits referred to Jansenists as "the Hellenists' sect," an epithet perhaps not so far from the mark: in his testament, Racine asked to be buried at the foot of Monsieur Hamon, his professor of Greek.

PHILIPPE DE
CHAMPAIGNE
(1602–1674)

*Catherine Arnaud
and Catherine de
Sainte-Suzanne at
Port-Royal*

Musée du Louvre,
Paris

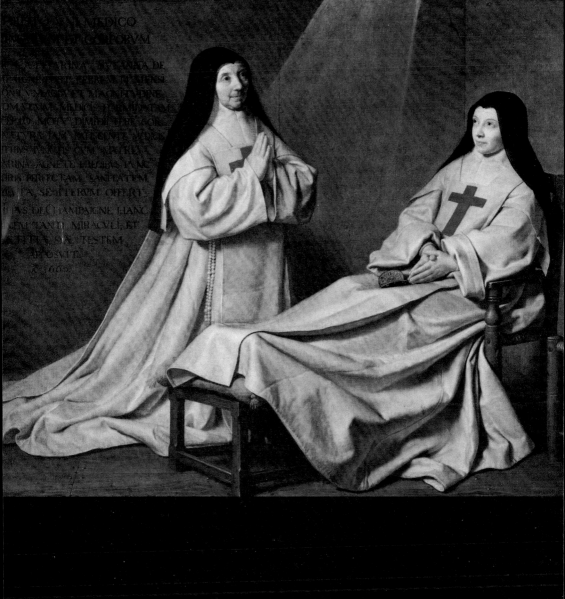

The Eagle of Meaux

One of the most important religious arts, all but vanished in our day, was the art of sacred oratory—eloquence that put the subtleties of discourse at the service of preachers.

At the end of the thirteenth century, Jacobus de Voragine compiled *The Golden Legend* precisely to help the first Friars Preachers (the Dominicans) polish their sermons. The work was a collection of stories depicting the lives of saints, in which Voragine did not hesitate to include the fantastic and miraculous, all the while citing his sources.

The importance formerly given to preaching is illustrated by the career of the greatest master of the genre: Jacques Bénigne Bossuet. Ordained a priest in 1652, he soon gained such a following that he was appointed tutor of the dauphin, son of Louis XIV. He never hesitated to pronounce strongly critical sermons before the king himself, and his funeral orations for the greats of this world—Henriette of France, Henriette of England, the princess Palatine, the prince of Condé, and so on—have been included in literary anthologies.

He came into conflict with another great preacher of his time, François Fénelon. Bossuet, styled the Eagle of Meaux (his diocese), had Fénelon—styled the Swan of Cambrai, tutor of the king's grandson—condemned as the defender of the doctrine of Quietism, which advocated mystical union with God while spurning all activities of the soul.

Hyacinth Rigaud
(1659–1743)

*Jacques Bénigne
Bossuet*

Musée du Louvre,
Paris

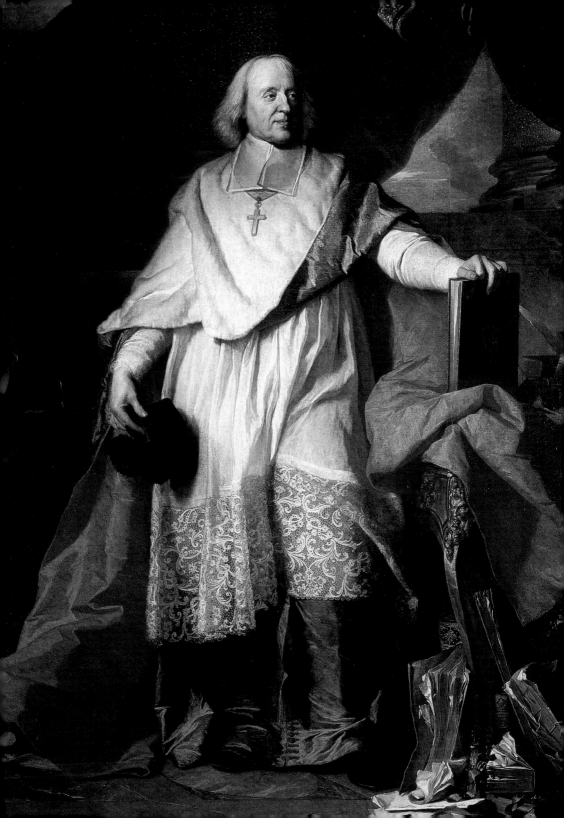

From Upheavals to Concordats

Periods of turbulence are generally not conducive to artistic expression of the faith; so much more, then, did the French Revolution quell the religious inspiration of artists. At the height of the confusion, nonjuring priests were being persecuted because of their refusal to subscribe to the civil constitution imposed on the clergy, all the goods of the church were being confiscated, and monasteries were being emptied by force; at the same time, Hébert and his *enragés* partisans were guillotined for being atheists!

It took an agreement between Pius VII and the Consul Napoleon Bonaparte, the Concordat of 1801, to bring a minimum of serenity back to the country. In it, Catholicism was recognized as the religion of the majority of the French "and that of the consuls." Nonetheless, Bonaparte waited until 1804 and the eve of his consecration as emperor — a privilege that he had extorted from the pope — to marry Josephine in a religious ceremony.

He divorced his wife in 1809 to marry the Archduchess Marie-Louise of Austria. The wedding was celebrated by Cardinal Fesch, an uncle of Napoleon, at a time when the emperor was under excommunication for having annexed the papal states.

Nevertheless, the concordat signed with France would serve as a model for 30 other agreements that the Catholic Church entered into between 1815 and 1830, most notably with Bavaria, Switzerland, the kingdom of Naples, Germany, and Russia.

JACQUES-LOUIS
DAVID
(1748–1825)

The Consecration of Napoleon

Musée du Louvre, Paris

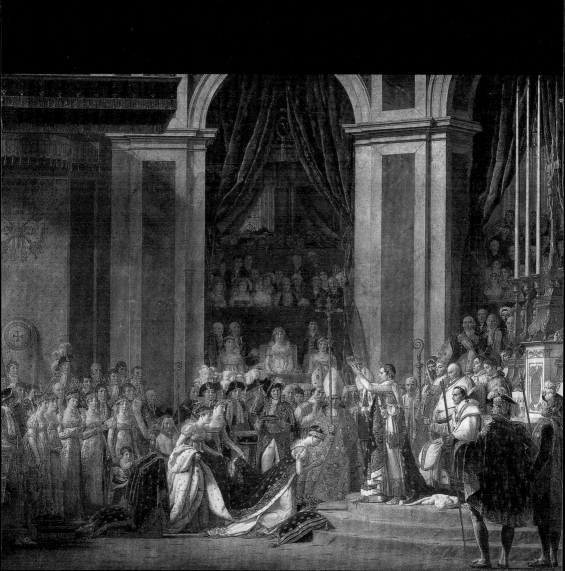

Mounting Criticism

Antireligious polemics are as old as religion itself, and have been expressed more or less openly according to the times. In the seventeenth century, the French poet Nicolas Boileau-Déspreaux already attacked the ostentation of one's impiety as being a form of snobbishness:

> Vois-tu ce libertine en public intrépide,
> Qui prêche contre un Dieu que dans son âme il croit?
> Il irait embrasser la vérité qu'il voit;
> Mais de ses faux amis il craint la raillerie,
> Et ne brave ainsi Dieu que par poltronnerie.

> [Seest thou this intrepid public libertine,
> preaching against a God in whom, within his soul, he believes?
> He would embrace the truth that he sees;
> But he fears the mockery of his false friends,
> So thus defies God solely out of cowardice.]

Starting with Voltaire and the philosophers of the Enlightenment, the Inquisition (particularly the Spanish Inquisition) became the target par excellence of indignation and the unbridling of the imagination. Edgar Allan Poe's short story, "The Pit and the Pendulum," is a masterpiece in this regard, including the invention of the most terrifying tortures.

The Spanish Inquisition was abolished by Napoleon in 1808, a decision opposed by Joseph de Maistre, a key figure of French counter-revolutionary thought, in his 1822 *Lettres sur l'Inquisition espagnole:* "The abuses perpetrated by ancient institutions prove nothing against their fundamental merit, and I hold that nations have everything to lose from abolishing their ancient institutions, instead of perfecting and correcting them."

Nonetheless, at the example of Goya, the Romantic period created an effusion of paintings depicting scenes of the Inquisition, often quite horrific.

Francisco Goya
(1746–1828)

The Tribunal of the Inquisition

Real Academía de Bellas Artes de San Fernando, Madrid

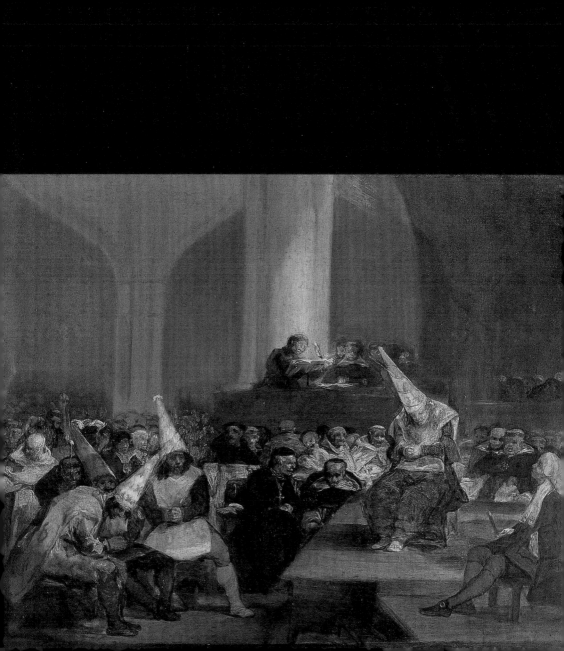

The East Stirs

During the many centuries they lived under Ottoman domination, the Greeks remained true to their Orthodox faith. In the nineteenth century, the decline of the Turkish Empire along with the rise of nationalism in Europe incited a revolt for an independent Greece. Beginning in 1820, the struggle was backed by a true religious mobilization.

The Ottomans responded to the insurrection of 1821 by unleashing terror. In Constantinople, the patriarch Gregory V was hung at the door of the patriarchate. In the island of Chio alone, the massacres annihilated 70,000 Greeks.

In the West, the public was aghast. Eugene Delacroix created his work *The Massacres at Chio* in 1824, and Victor Hugo lamented, "Les Turcs ont passé là. Tout n'est que ruine et deuil. / Chio, l'île des vins, n'est plus qu'un sombre écueil" [The Turks have come by. Ruin and pain on every side. / Chio, the isle of wines, is but a somber abandoned reef].

That same year, Lord Byron died within the walls of Messolonghi in Greece. Europe could not but intervene, and in 1827, the Turco-Egyptian fleet was destroyed in Navarino. The Sublime Door was forced to accept the independence of Greece.

As the state religion of Greece, Orthodoxy has held a strong ascendancy over the country, still evident today. Faithful to tradition, Orthodox Christians of the East continue to acknowledge the symbolic supremacy of the Patriarch of Constantinople, even though the Greek Orthodox have all but vanished from the city.

HUGUES FOURAU
(1803–1873)

*The Martyrdom
of the Patriarch
Gregory V*

Hôtel de Ville,
Auray

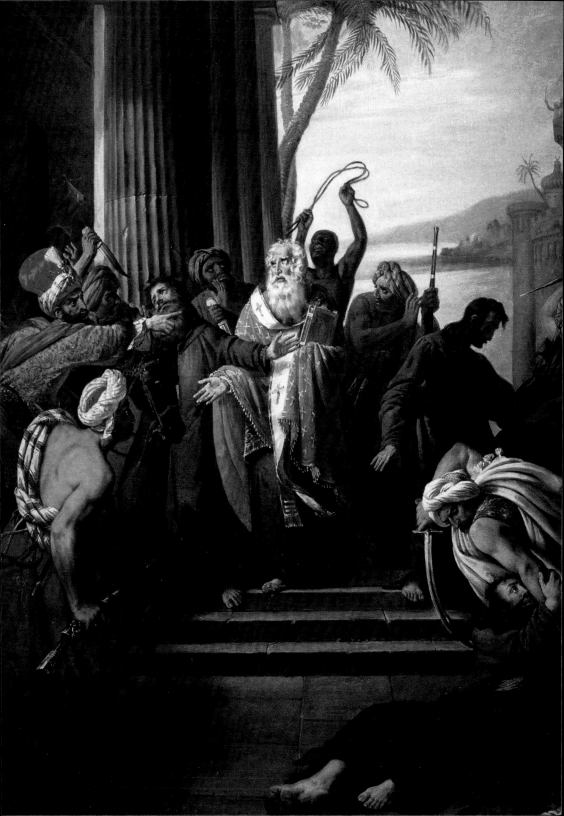

The Way of Compromise

In the France of the Restoration, there was a complete divide between the partisans of the Catholic and monarchist counterrevolution, and a coalition of old republicans, new liberals, and those nostalgic for the empire.

An odd movement then emerged, at once papist and democratic, fundamentalist and libertarian, which advocated an absolute separation between church and state and also demanded the freedom to establish schools independently of the government's system. (The government forbade teaching by nonapproved religious congregations, such as the Jesuits.)

The movement was headed by an improbable trio: Father Félicité de Lammenais; Henri Lacordaire, a Dominican; and the very noble Count Charles de Montalembert. Together, they founded the newspaper *L'Avenir,* which enjoyed a large readership. Upon the restitution of the monarchy in July 1830, they attempted a type of intellectual coup — the establishment of a "free school." A legal process ensued. The 21-year-old Montalembert, as a member of the French Chamber of Peers, could only be judged by this body. When he presented himself before the Chamber, he cited "schoolmaster" as his profession, both a challenge and statement.

Not until 1850 would freedom of education be secured, under the Second Republic, a regime that Montalembert and his allies supported. However, this paradoxical position gained them enemies in both camps. Soon, the Vatican condemned what it perceived to be their "unbridled ardor of an audacious independent spirit."

Lamennais refused to concede. Lacordaire and Montalembert submitted to Rome's judgment and continued to fight from within the bosom of the church. To them can be traced the compromise that is still operative in France, as well as the movement that calls for a Christian democracy.

THÉODORE
CHASSÉRIAU
(1819–1856)

*Father Dominique
Lacordaire*

Musée du Louvre,
Paris

Globalization

With the upheavals of the French Revolution and empire having ended, Christian Europe resumed its missionary efforts, which had very nearly been interrupted. Furthered by the surge of foreign expeditions and the development of new means of transportation in the nineteenth century, the church's work of evangelization reached into every corner of the globe, often preceding the arrival of Western settlers, and sometimes acting as a catalyst for them.

Thus, the very anticlerical Prime Minister Jules Ferry (1832–93), known for his advocacy of colonialism, launched his offensive into northern Vietnam on the paths opened by Pierre Borie, a missionary martyred in 1838.

In Korea, the presence of French missionaries provoked a diplomatic imbroglio that still has not been resolved. To avenge the execution of nine French priests (besides the massacre of the 8,000 Koreans they had converted), the regime of Napoleon III sent a punitive expedition to ravage the island of Kanghwa, where the venerated archives of the Choson dynasty were kept. Thanks to the underhanded deftness of French navy troops, the most precious historical archives of Korea made their way to the Bibliotèque Nationale in France and there remained, despite Korea's demands for restitution.

The French Republic refused to part from its national patrimony; little did it matter that it had been obtained by pillage. In 1993, François Mitterand sent two volumes from the collection to Seoul, on "permanent loan."

VIETNAMESE, ANONYMOUS (contemporary with events, 1838)

Beheading of Father Pierre Borie

Maison des Missions Étrangères, Paris

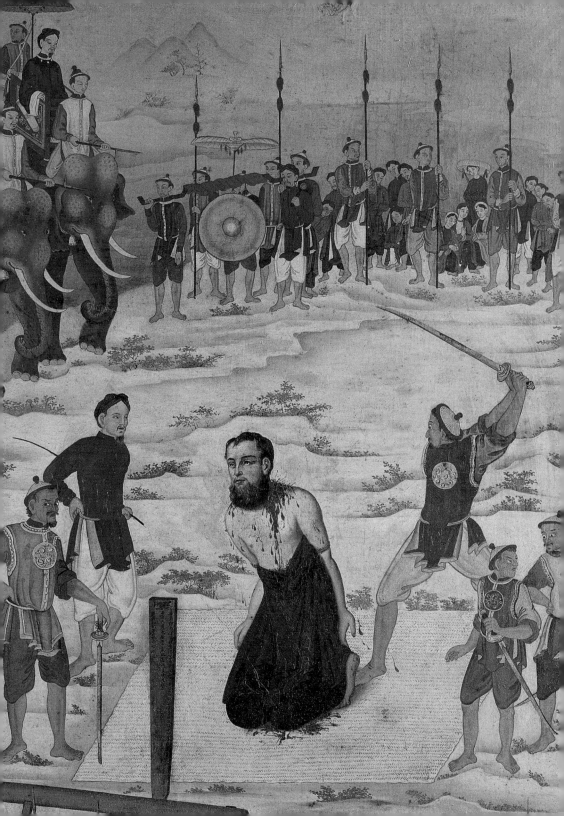

Pius IX's Great Turnabout

In all of papal history, the long pontificate (1846–78) of Pius IX had the most reversals and innovations. First, circumstances of history narrowed his powers to the moral realm alone. He was deprived of the greatest portion of the pontifical states — Emilia Romagna, Le Marches and Umbria — by the activities of Garibaldi and the formation of the Republic of Italy. As to Rome, the pontifical zouaves, a great number of whom were volunteer Frenchmen, could only delay the inevitable — in 1870, the royal Italian army seized the Eternal City. Thenceforth, the pontiff would be a prisoner in the Vatican. Not until the 1929 concordat with Mussolini would the Holy See secure the status it now holds as a city-state.

His territorial troubles, however, did not keep Pius IX from conducting a great doctrinal offensive. Through his *Syllabus*, a catalogue of 80 condemned propositions, he definitively (he thought) rejected liberal doctrines that were circulating at the time.

Most importantly, he defined the dogma of the Immaculate Conception in 1854, which the apparitions at Lourdes confirmed four years later. Then the First Vatican Council, in 1870, proclaimed the dogma of papal infallibility in matters of faith and morals when the pope acts *ex cathedra*, which has only occurred once since then, with Pius XII's pronouncement of the dogma of the Assumption in 1950.

MICHELANGELO
PACETTI
(1793–1855)

*Preaching of Pius
IX on the Forum*

Museo Nazionale
Romano, Rome

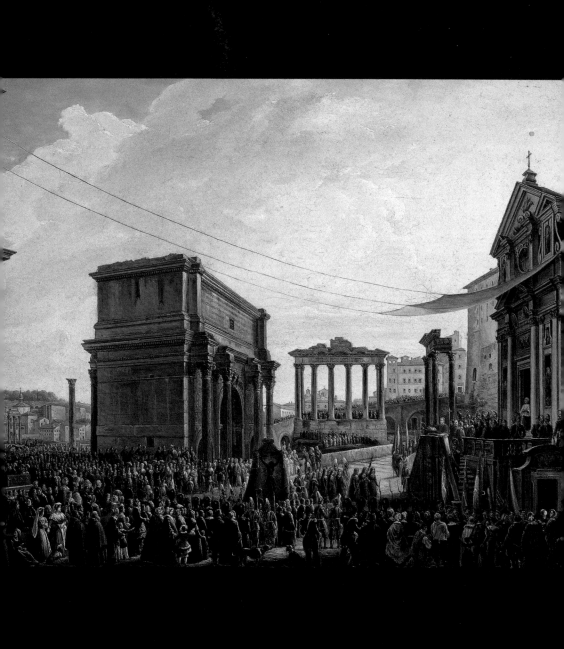

Bound for Africa

The great affair of the end of the nineteenth century was the evange-lization of black Africa. Whether because of timidity or lucidity, there was never any real attempt — except for Charles de Foucauld's — to convert the Muslims of northern Africa after the French conquest of Algeria in 1830.

On the other hand, the "pagans" of the black continent were the object of all manner of solicitude. France, Belgium, and Italy provided veritable battalions of Catholic missionaries that covered the colonies as the settlements spread. However, they came upon an unprecedented phenomenon: competition from Protestant missionaries, and not only in the British colonies.

Today, it is difficult to appreciate the popularity that the missions enjoyed between 1850 and 1950, a period when enthusiasm for the evangelization of peoples, combined with a desire to "civilize" them, carried an aura of heroism and gallantry. And they achieved their objective: the old Europe of the missions has now largely become a minority in the religious demography of the world.

CHARLES-
LOUIS FRÉDY DE
COUBERTIN
(1822–1908)

*Departure of
the Missionaries
(among Known
Personalities; the
Composer Gounod
Embraces a
Missionary Priest)*

Maison des
Missions
Étrangères, Paris

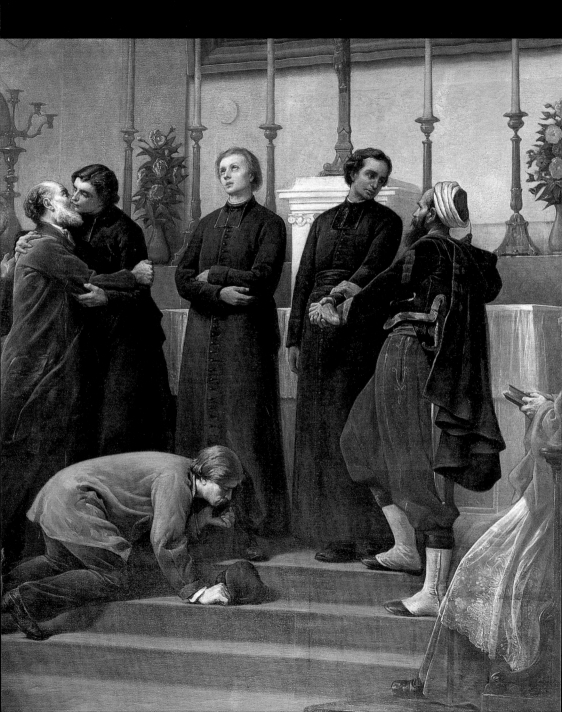

The Greatest Persecution

At least 20 million martyrs of the faith! Western Christianity has not yet truly grasped the depth of tragedy brought about by the triumph of communism in Russia, and then in Eastern Europe and the nations of the Far East. As this concerned mostly Orthodox nations, there has been a tendency to minimize the immensity of the cataclysm born out of the clash of two distinct ideological universes.

At the dawn of the twentieth century, Orthodoxy was experiencing a period of extraordinary dynamism. This all came to a rude halt. Christian communities in China were purged, followed by the churches in Cambodia, Vietnam, and Laos. It may be little diplomatic, but not entirely useless, to recall that not all of them have yet recovered their freedom.

Ilia Efimovich
Repin
(1844–1930)

*Procession in the
Province of Kursk*

The State Tretiakov
Gallery, Moscow

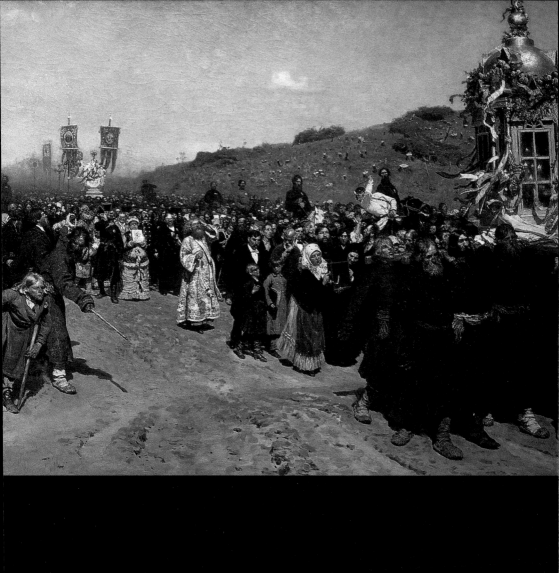

EASTERN FLORIDA STATE COLLEGE
MELBOURNE CAMPUS LIBRARY
3865 N. WICKHAM ROAD
MELBOURNE, FL 32935

Photo Credits

Akg-images: pp. 23, 25, 27, 31, 37, 39, 41, 49, 55, 59, 63, 65, 67, 73, 75, 83, 85, 87, 93, 95, 99, 103, 105, 107, 117, 129, 131, 139, 145, 149, 155, 157, 161, 165, 169, 171, 175, 177, 181, 185, 189, 191, 193, 203, 207, 211, 213.

Erich Lessing / Akg-images: pp. 21, 29, 33, 43, 45, 47, 61, 69, 77, 79, 81, 87, 109, 113, 119, 133, 135, 137, 141, 143, 183, 195, 197, 199, 205, 209, 215, 223.

Cameraphoto / Akg-images: pp. 17, 53, 91, 97, 101, 163, 173.

S. Domingie / Akg-images: pp. 35, 57, 151, 179.

British Library / Akg-images: pp. 115, 121, 123, 125.

Nimatallah / Akg-images: pp. 51, 147, 219.

Rabatti-Domingie / Akg-images: pp. 111, 153.

Jean-François Amelot / Akg-images: pp. 217, 221.

Pirozzi / Akg-images: p. 19.

Schadach / Akg-images: p. 71.

Laurent Lecat / Akg-images: p. 127.

Gilles Mermet / Akg-images: p. 159.

Sotheby's / Akg-images: p. 167.

Archives CDA / Guillemot / Akg-images: p. 187.

Joseph Martin / Akg-images: p. 201.